California
THE BEAUTIFUL

California
THE BEAUTIFUL
Spirit and Place

Text compiled and edited by Peter Beren
Photographs by Galen Rowell

welcome
BOOKS

VIA
BOOKS

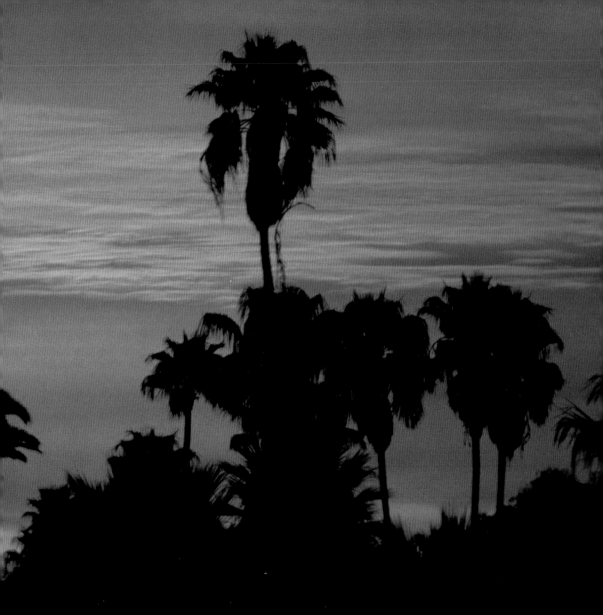

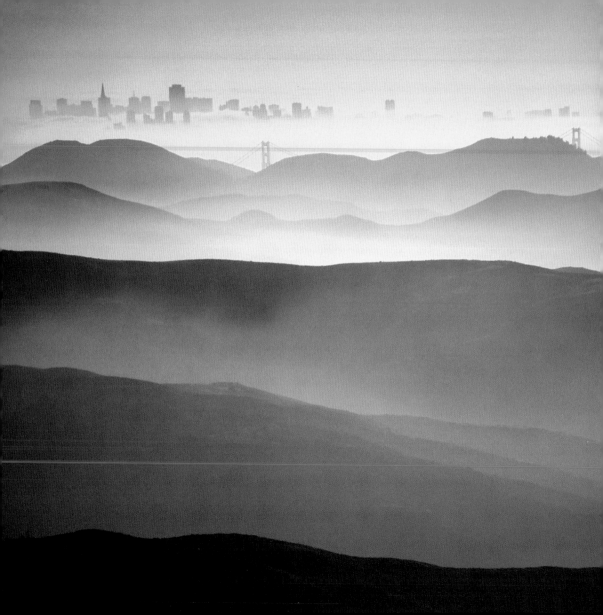

California native son Galen Rowell (1940–2002) was often called "the new Ansel Adams." An accomplished mountaineer, he was equally at home discussing the science of human perception or the nutritional merits of whale blubber and hot Tang. Although he had been on expeditions to all seven continents around the globe, whenever he returned home to California, he often said that he lived in one of the most beautiful places on earth.

Paired with quotations from fifty-five California writers, eighty-five of Galen Rowell's enduring images are presented here, some classic and some new, sharing his vision of the natural beauty of his home state.

PETER BEREN, *Editor*

View of San Francisco and the Golden Gate Bridge
Marin County

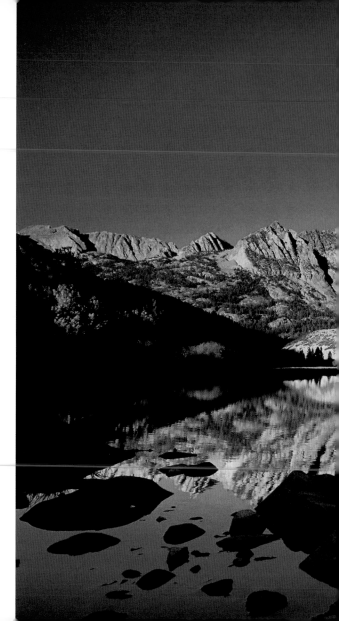

AT THE EDGE of
geographic possibility
and under a paradisiacal
sun, California
traditionally has played
America's wild child.
America's America.

— RICHARD RODRIGUEZ

Fall reflections in North Lake
Eastern Sierra

6

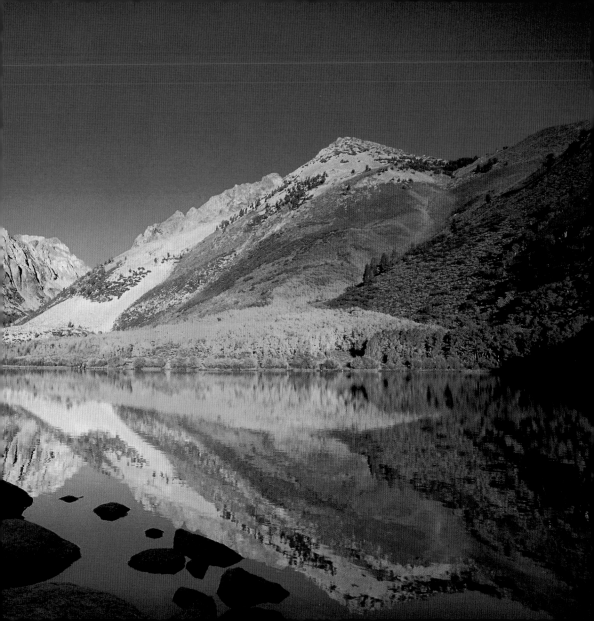

Santa Barbara coast
Santa Barbara

ARRIVING IN CALIFORNIA from the East, you gain the impression of entering into the land of Paradise. And not only if you arrive in winter....An arrival in California takes on more interest when the circumstances are more equal; when, for instance, the sun shines forth with as great intensity in the East and Middle West and in the Rocky Mountains as on the shores of the Pacific; when the whole land is covered with green and the entire sky is heavenly blue; when all that beauty is absolutely true. Then one still feels (and this time without tricks or playing false with the seasons) that one has entered Paradise.

— JULIÁN MARÍAS

FOR ALL the toll the
desert takes of a man it
gives compensations, deep
breaths, deep sleep, and the
communion of the stars.

— MARY AUSTIN

Joshua trees
Mojave Desert

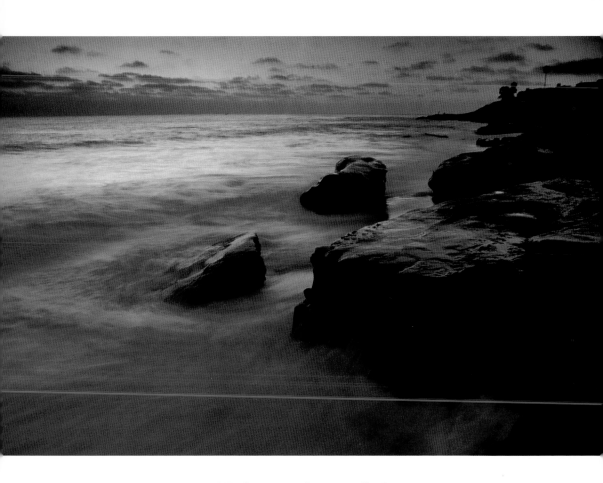

Windansea Beach at La Jolla Cove
San Diego coast

A SOUND LIKE RADIO STATIC comes from the seaward mist, nearly drowning the surf noise. As the day progresses and the mist burns off, I find the sound is made by hundreds of sea birds on the sandbars or floating offshore. There are gulls, pelicans, cormorants, guillemots, sandpipers, terns. There must be schools of fish running; the birds are excited.

— DAVID RAINS WALLACE

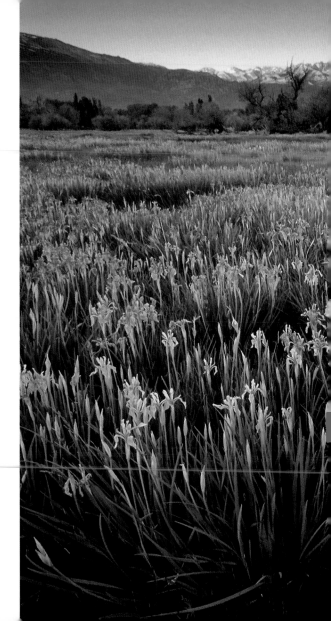

OF ALL the many seasons of the California year, February is the most beautiful.... In February fresh grass sprouts overnight, a bright, iridescent green suddenly flooding the landscape. Fruit trees bloom, the tule fog disappears, and the sun shines as brightly as in summer, without parching the land.

— DOROTHY BRYANT

Wild iris at dawn
Bishop

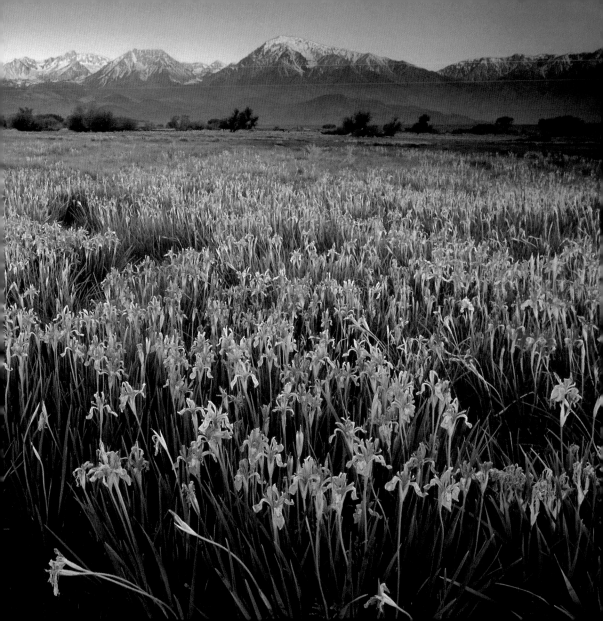

HERE IS A CLIMATE that breeds vigor, with just sufficient geniality to prevent the expenditure of most of that vigor in fighting the elements.

— JACK LONDON

16

(opposite)
Snow-bent aspen trunks
South Fork, Bishop Creek, Eastern Sierra

(overleaf)
Full moon rising over Mt. Lyell and Lyell Glacier
Yosemite National Park

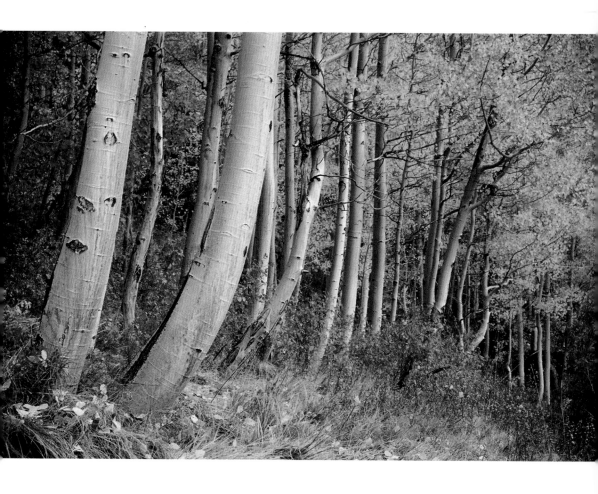

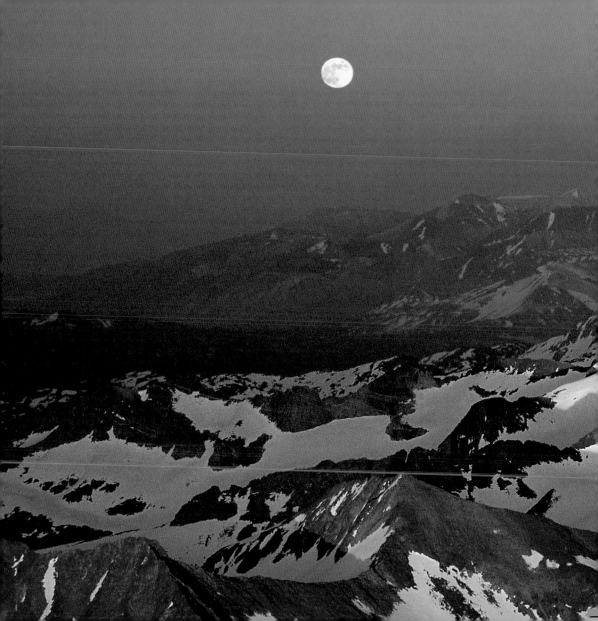

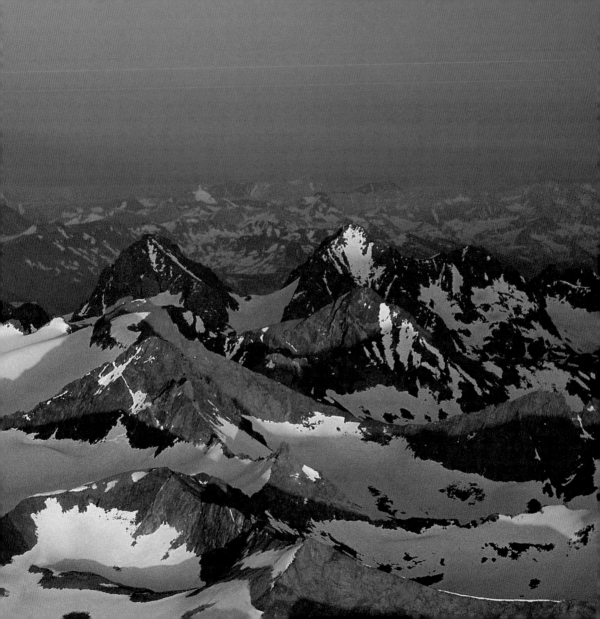

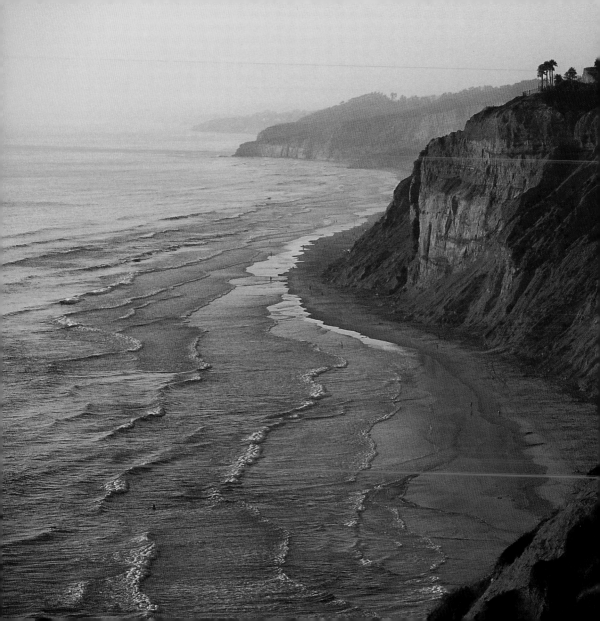

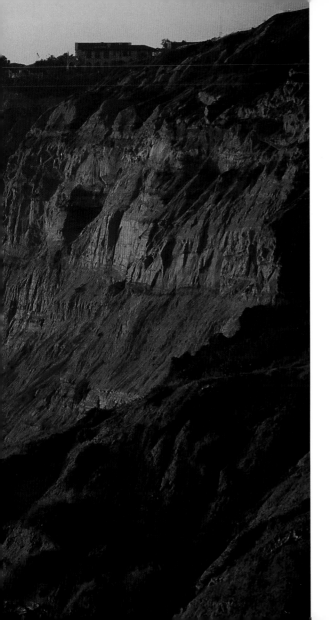

IN EVERY COVE

along the line of
mountains the fog was
being piled in higher and
higher, as though by some
wind that was inaudible
to me. I could trace its
progress, one pine-tree
first growing hazy and
then disappearing after
another; although
sometimes there was none
of this forerunning haze,
but the whole opaque
white ocean gave a start
and swallowed a piece of
mountain at a gulp.

— Robert Louis Stevenson

Black's Beach
La Jolla

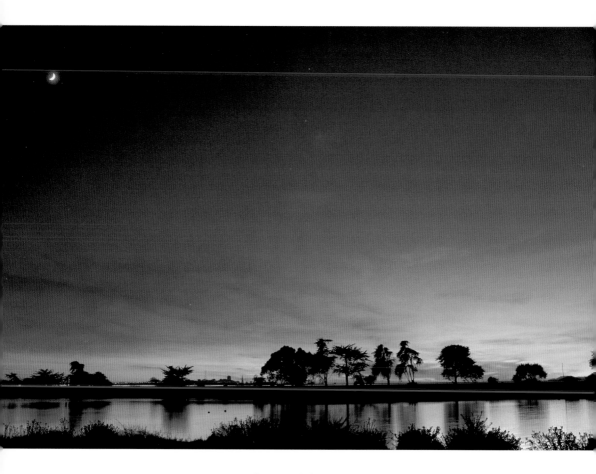

Sunset from Berkeley's Aquatic Park
On San Francisco Bay

CALIFORNIA is not so much a state of the Union
as it is an *imagination* that seceded from our reality a
long time ago. In leading the world in transition from
industrial to post-industrial society, California's culture
became the first from coal to oil, from steel to plastic,
from hardware to software, from materialism to
mysticism, from reality to fantasy. California became
the first to discover that it was fantasy that led to
reality, not the other way around.

— WILLIAM IRWIN THOMPSON

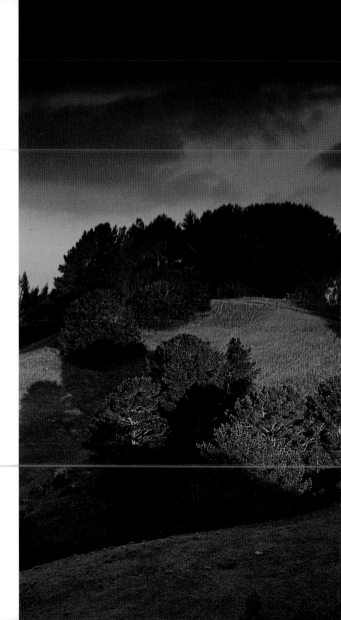

IT USED TO BE said that you had to know what was happening in America because it gave us a glimpse of our future. Today, the rest of America, and after that Europe, had better heed what happens in California, for it already reveals the type of civilisation that is in store for all of us.

— ALISTAIR COOKE

Stormy dawn
Sea View Trail

(overleaf)
Sierra Wave clouds over Round Valley near Bishop
Eastern Sierra

24

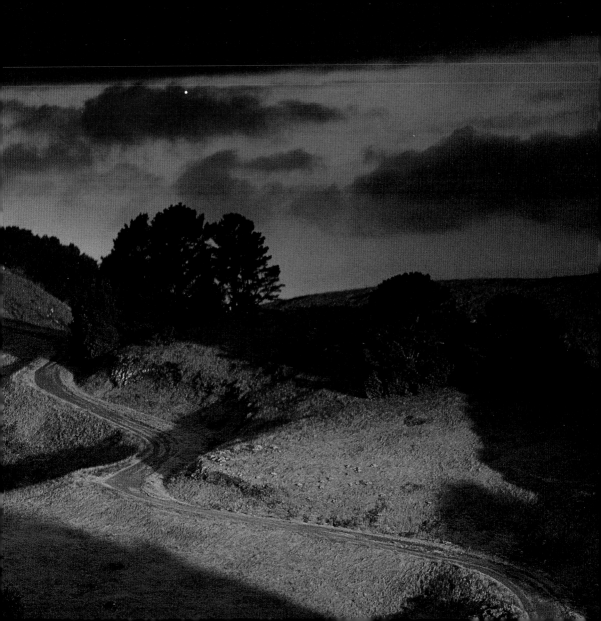

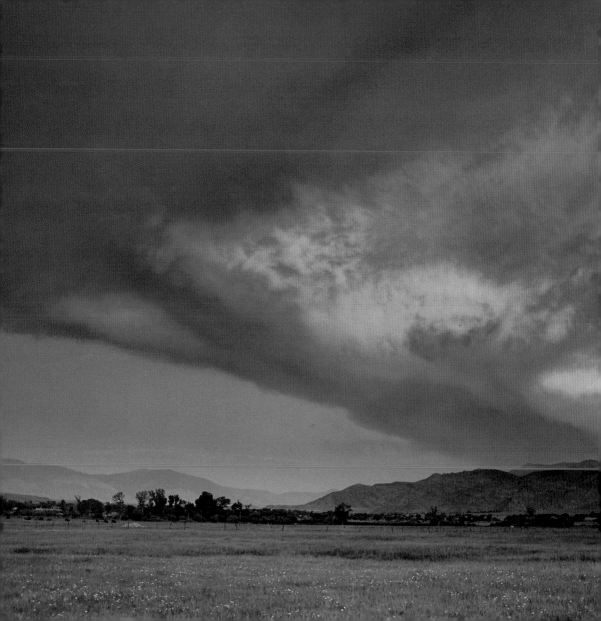

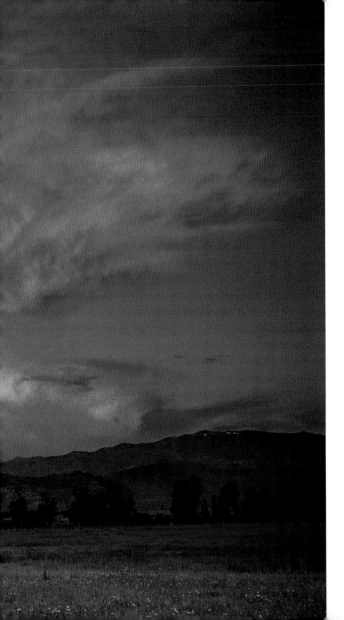

WE MAY LEARN
anew what compassion
and beauty are, and pause
to listen to the Earth's
music. We may see that
progress is neither the
accelerating speed with
which we multiply and
subdue the Earth nor the
growing number of
things we possess and
cling to. It is a way along
which to search for truth,
to find serenity and love
and reverence for life, to
be part of an enduring
harmony, trying hard not
to sing out of tune.

— DAVID BROWER

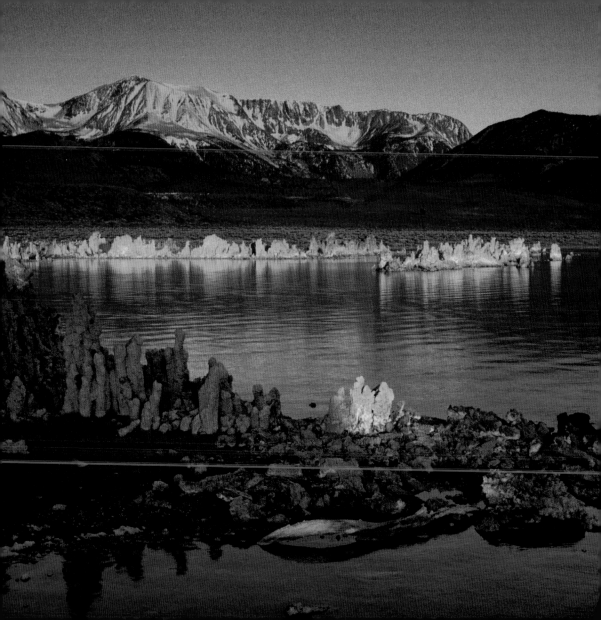

MONO LAKE, though it appears fresh and inviting, is actually a briny deep, in which nothing but one small species of saltwater shrimp and the larvae of one tiny black fly can live.... But the water that feeds Mono Lake will not go to waste much longer, for, soon purified, it will go into the new Mono Basin Aqueduct and help to slake the thirst of metropolitan Los Angeles.

— FEDERAL WRITERS' PROJECT, 1939

29

(opposite)
View of Mt. Dana at dawn
Mono Lake

(overleaf)
Sunflowers in twilight
Owens Valley

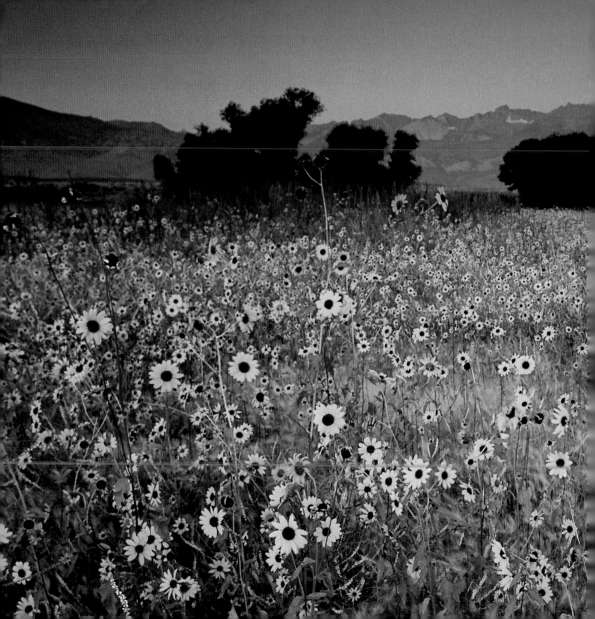

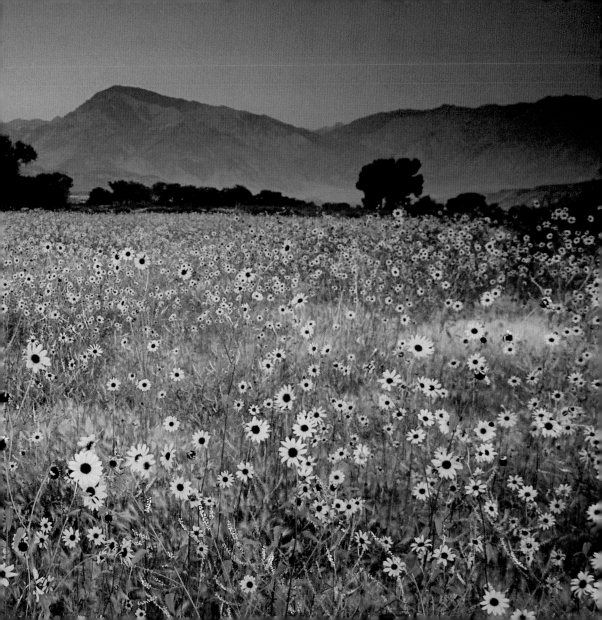

MORE SPECTACULARLY ENDOWED
than any other of the 50 states, culmination of the
American movement westward, neighbor to Asia,
raw, young, powerful, yet with oases of
extraordinary sophistication and a smattering of
every cultivated grace, California is a place where
you can find whatever you come looking for.

— WALLACE STEGNER

Evening clouds over the Owens River near Bishop
Eastern Sierra

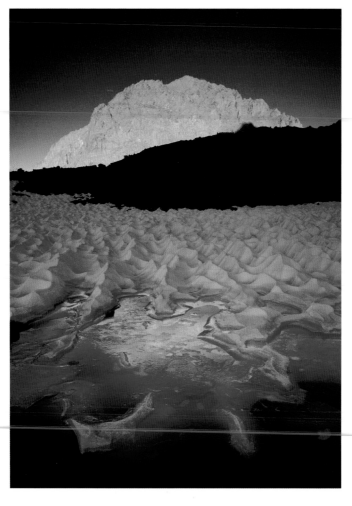

Late summer snow under Mt. Williamson
High Sierra

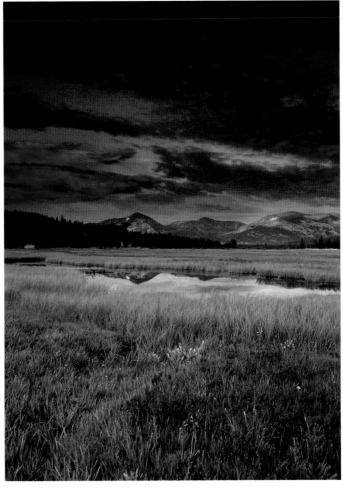

Owl's clover at sunset, Tuolumne Meadows
Yosemite National Park

AS LONG AS I LIVE

I'll hear waterfalls and birds and winds sing.
I'll interpret the rocks,
Learn the language of the flood, storm,
and the avalanche.
I'll acquaint myself with the glaciers
and wild gardens,
And get as near the heart of the world as I can.

— JOHN MUIR

Palm Canyon
Anza-Borrego Desert

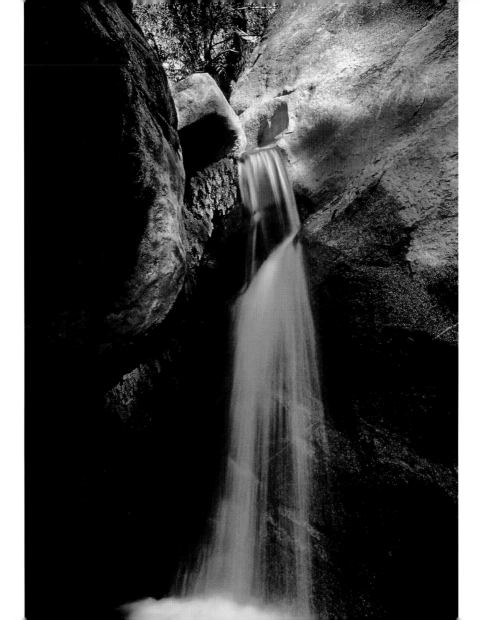

WE DON'T HAVE to tell the seeds of the bristlecone pine what to do. We give them a chance. Or God does. Or Whom It May Concern does. Now, I'm not about to tell a bristlecone, or for that matter, a western swallowtail, a condor, or a redwood, what to do.... They know.... We have no right to drive these miracles off the Earth.

— DAVID BROWER

(opposite)
Bristlecone pine and evening storm
White Mountains

(overleaf)
Tule elk at sunset
Point Reyes National Seashore, Marin County

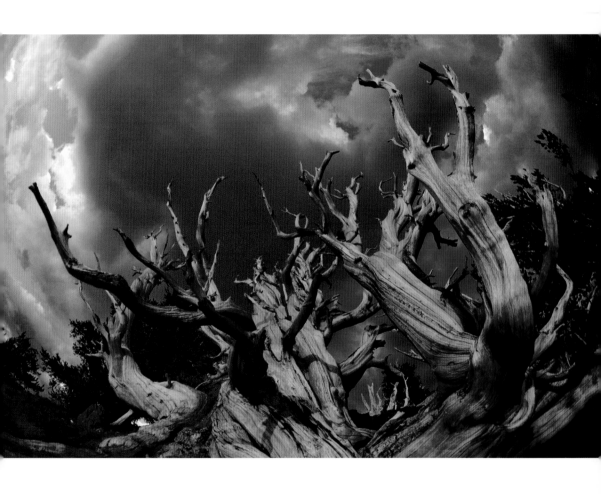

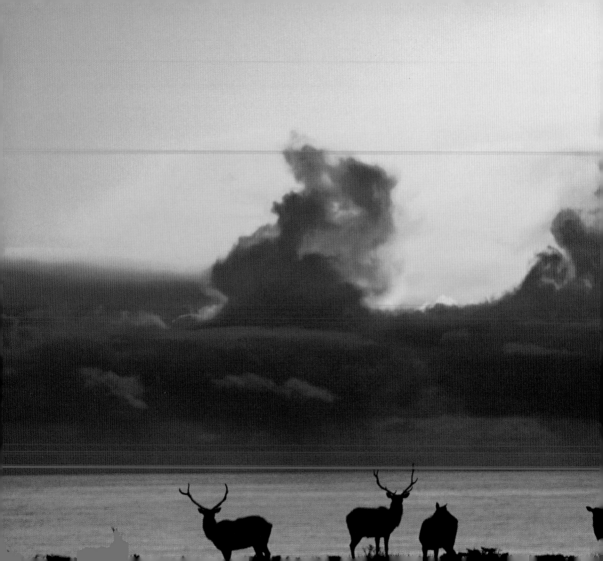

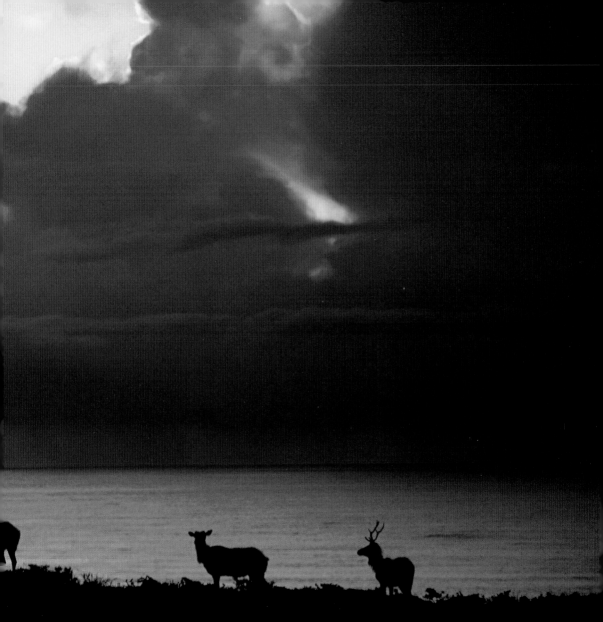

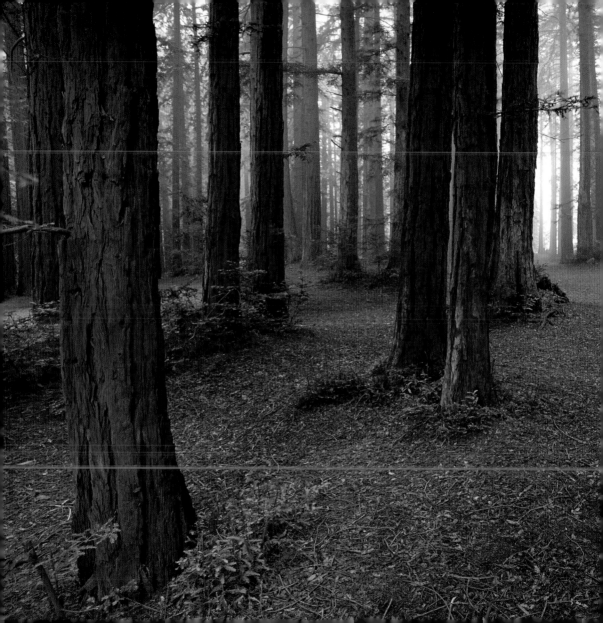

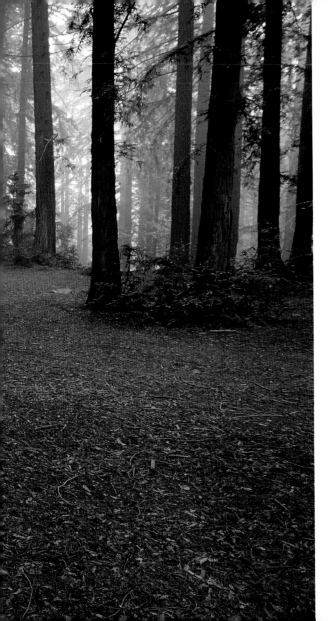

LET US LEARN

the secret languages of
light again. Also the
letters of the dark.
Learn the flight patterns
of birds, the syllables of
wolf howl and bird
song.... Let us, thus,
reconstitute the world,
sign by sign and melody
by melody.

— DEENA METZGER

43

Redwoods in fog
Redwood Regional Park
Oakland hills

THESE ROCKS are full of texts and teaching—these cliffs are tables of stone, graven with laws and commandments.
I read everywhere mysterious cyphers and hieroglyphics; every changing season offers to me a new palimpsest.

— CHARLES WARREN STODDARD

44

Sierra Wave cloud over petroglyphs
Owens Valley near Bishop

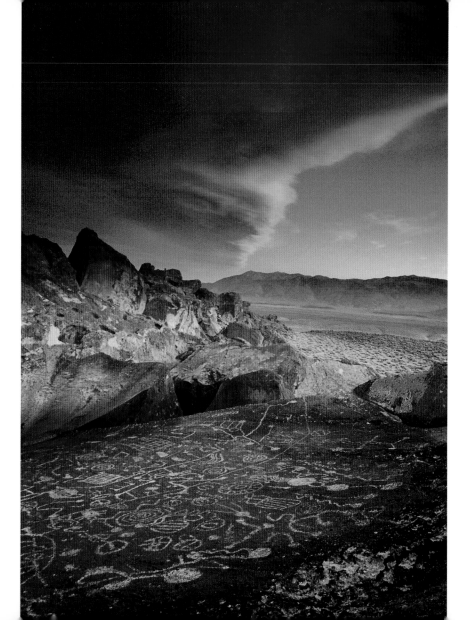

NATURE has no
mercy at all. Nature
says, "I'm going to snow.
If you have on a bikini
and no snowshoes, that's
tough. I am going to
snow anyway."

— MAYA ANGELOU

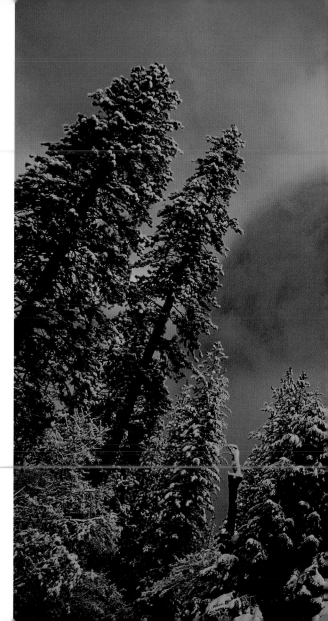

Clearing storm over El Capitan
Yosemite National Park

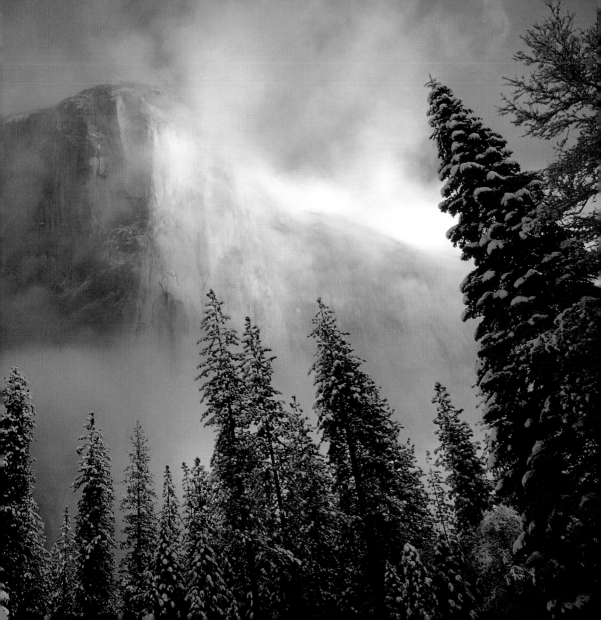

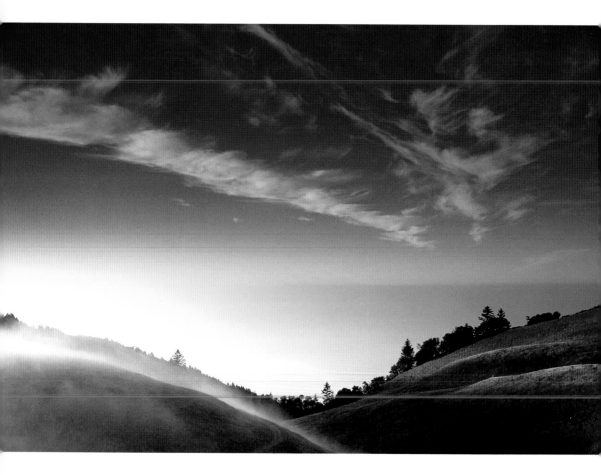

Dawn on Bolinas Ridge, Mt. Tamalpais
Marin County

THIS IS THE LAST PLACE.
There is nowhere else to go.
This is why
once again we celebrate the

Headland's huge, cairn-studded fall
into the sea.

— LEW WELCH

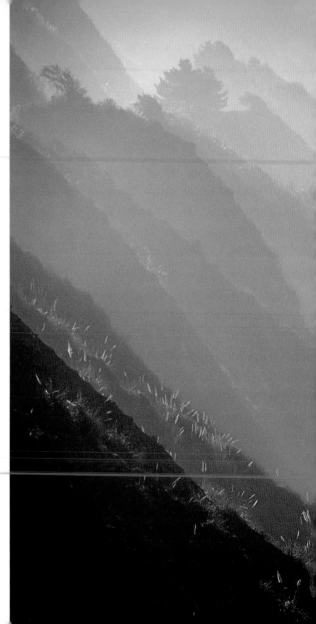

I ALWAYS want to
go north. North up the
coast, the destination
doesn't matter—Santa
Barbara, Cambria, Palo
Alto, San Francisco.
What matters is the
chilly air and ocean
light, the promise
of the unknown
steadily uncoiling as
you skim the edge of
the continent.

— APRIL SMITH

Foggy morning
Big Sur coast

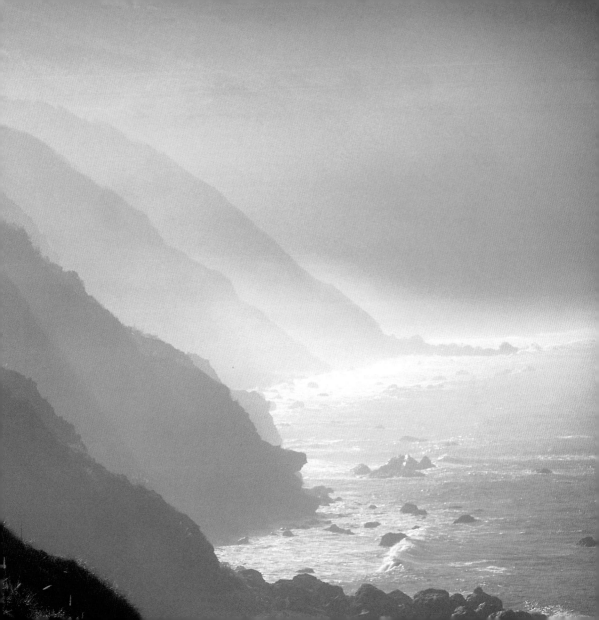

NOWHERE ON THE CONTINENT
did Americans find a more diverse nature, a
land of more impressive forms and more
powerful contrasts, than in California.

— WALLACE STEGNER

(opposite)
Converging hills in spring
Mt. Diablo

(overleaf)
Jeffrey pine and juniper on Olmsted Point
Yosemite National Park

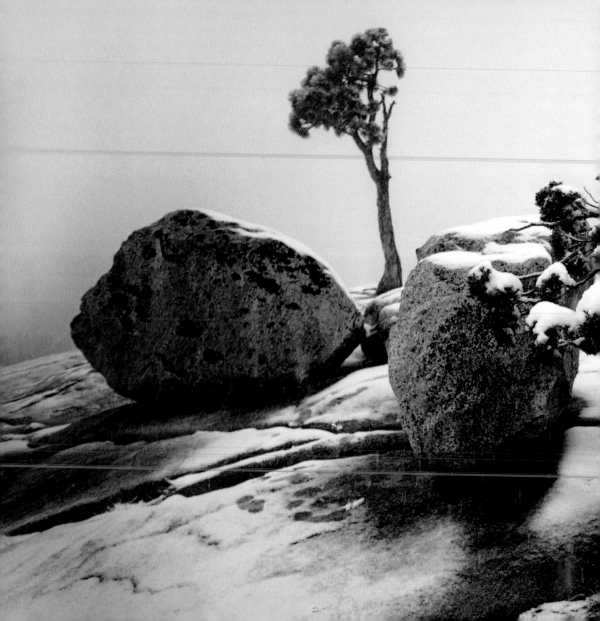

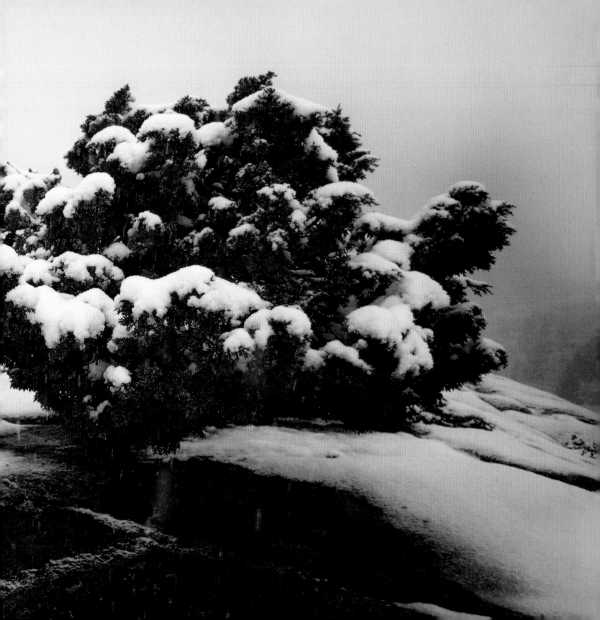

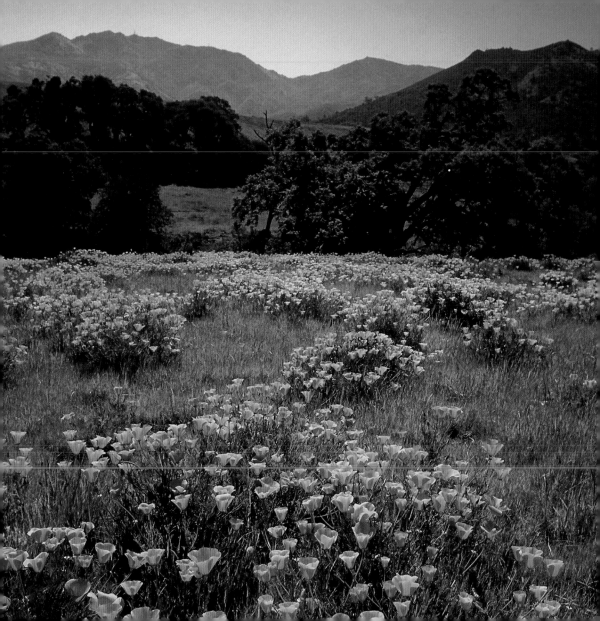

AS THEY WAITED FOR ODD JOBS

the Valley burst forth
with one imperial color
poppies flung their gold over acres of sand
like all the bankers in California
gone raving mad

Women wept in wonder
and hunted fruit jars to can
the precious flowers...

— WILMA ELIZABETH MCDANIEL

California poppies
Mt. Diablo

AT EVERY STREAM the road skirted dizzy cliff edges, dived down into lush growths of forest and ferns, and climbed out along the cliff edges again. The way was lined with flowers—wild lilac, wild roses, poppies, and lupins. Such lupins!—giant clumps of them of every lupin shade and color.

— JACK LONDON

Summer dawn beneath Mt. Humphreys
Eastern Sierra

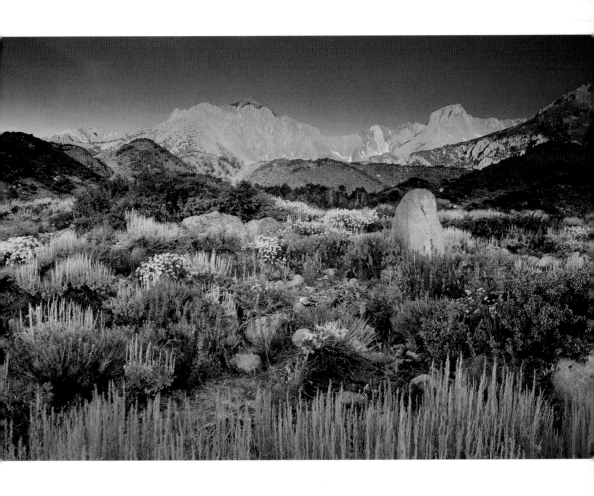

HERE, then, is the wonder we would all be…the
open mind, the wild heart, the good laugh, the mixed
company, the amiable companion, the stalwart lover,
and the guiltless colt.

— RAY BRADBURY

Mustangs beneath moon
White Mountains

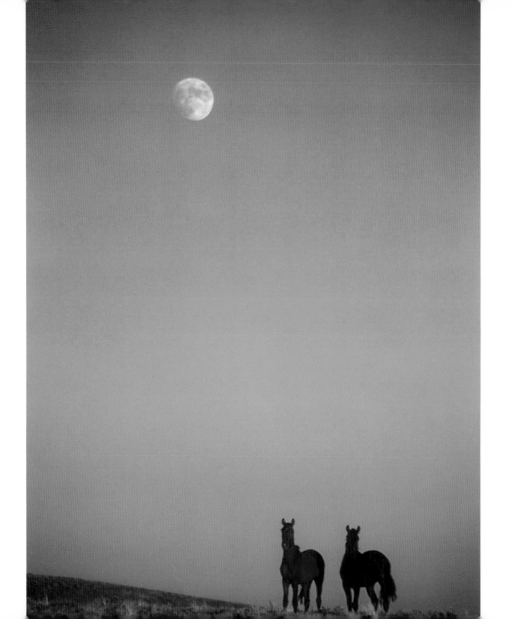

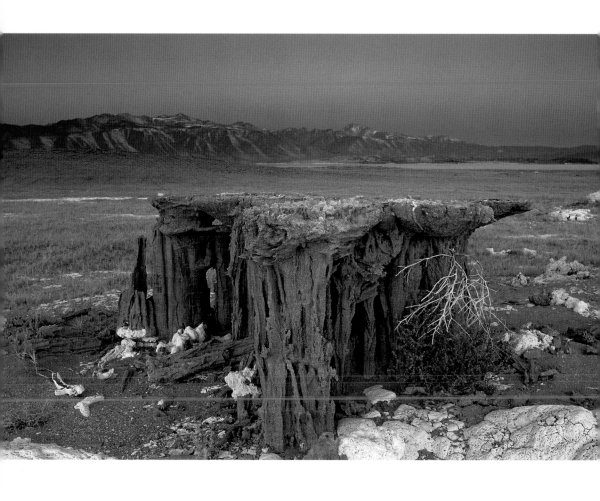

YOU MUST NOT CHANGE one thing, one
pebble, one grain of sand, until you know what good
and evil will follow on that act.

— URSULA K. LE GUIN

(opposite)
Alkaline sand columns emerging from ancient lake bed
Mono Lake

(overleaf)
Sunset on Mt. Shasta

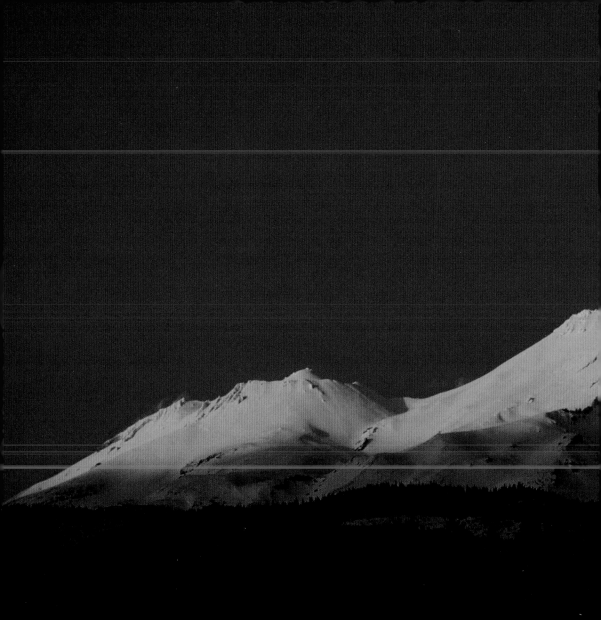

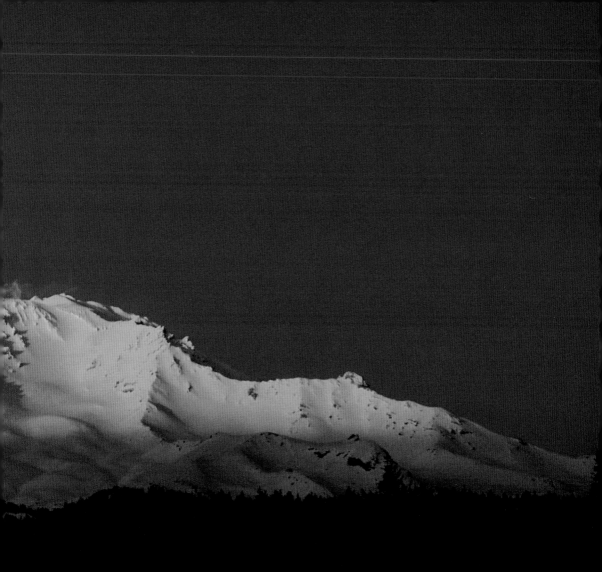

UNLIKE A MOUNTAIN forest or the ocean, rife with depth and secret, the desert's unveiled openness— its grand sweep of red-hot honesty—requires a period of adjustment and patient, contemplative observation. Desolation transforms under light's tutelage. Everyone ought to witness this transition and their own internal adjustment to it at least once. Preferably alone.

— CAMILLE CUSUMANO

Full moon at sunrise
Anza-Borrego Desert

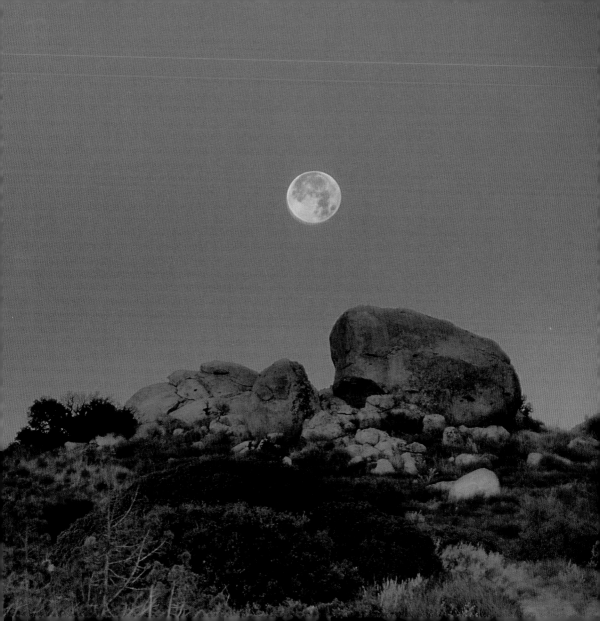

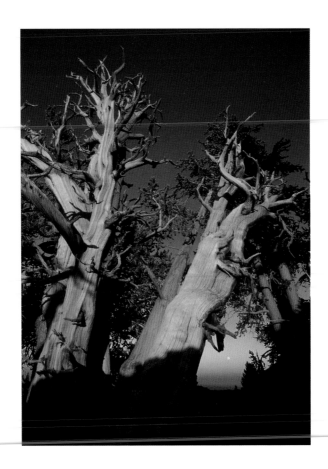

Alpenglow on pines with moonrise
White Mountains

Lenticular clouds over the Owens River
Eastern Sierra

A SECOND MILLENNIUM PASSES, with thirty more generations of the sons of men, and the sequoia shows no change but that he has settled at his base into a convex curve.... From then onward Time has no dominion over him, and the passage of centuries does but mark his inexhaustible fertility and power.

— J. SMEATON CHASE

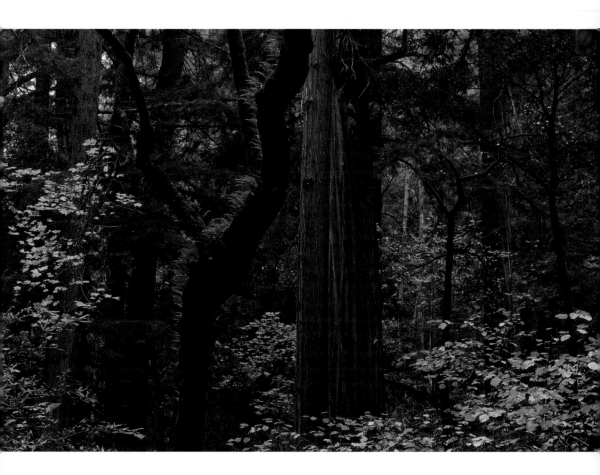

Coast redwood and bigleaf maple
Muir Woods National Monument

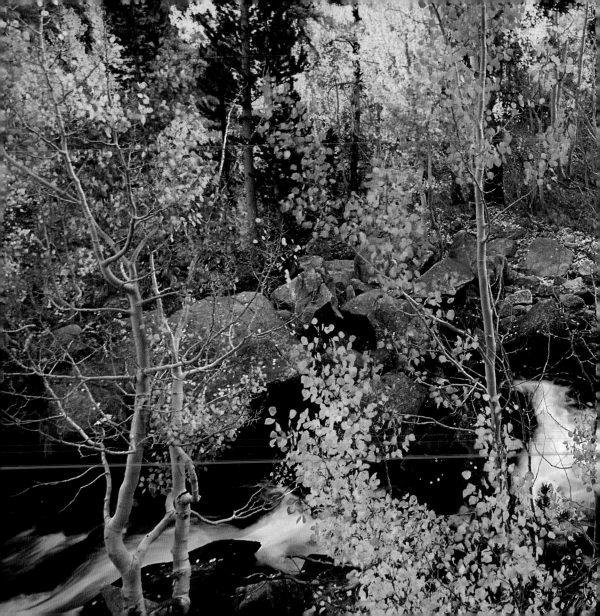

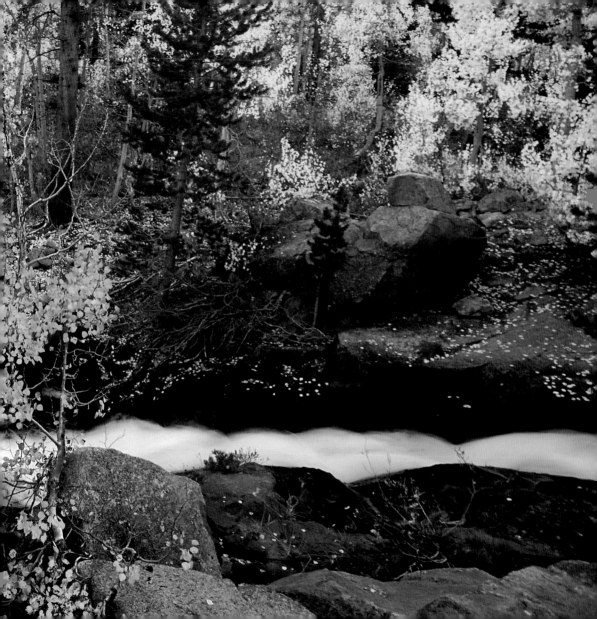

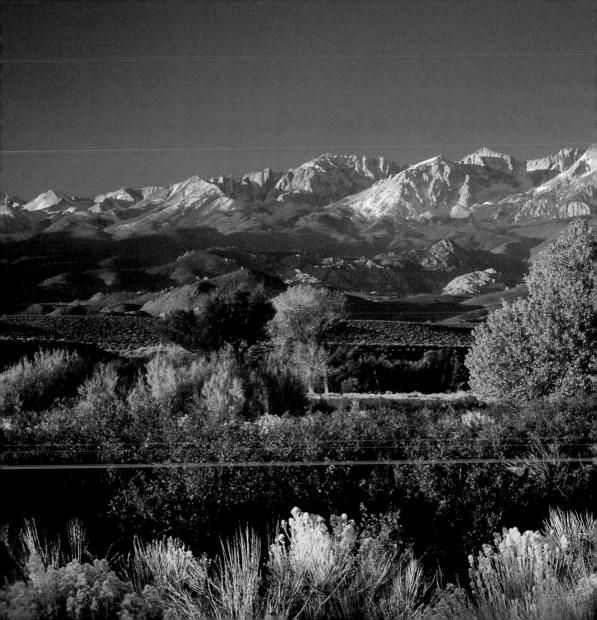

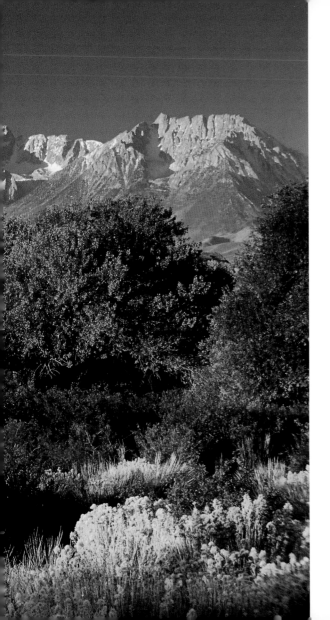

IN GOD'S wildness
lies the hope of the world. <inline-image> 75

— JOHN MUIR

(preceding spread)
Aspens and whitewater
South Fork, Bishop Creek,
Eastern Sierra

Fall colors
Eastern Sierra near Bishop

ALERT EYE LOOKING AHEAD, picking
the footholds to come, while never missing the step
of the moment. The body-mind is so at one with
this rough world that it makes these moves
effortlessly once it has had a bit of practice. The
mountain keeps up with the mountain.

— GARY SNYDER

Eichorn Pinnacle
Yosemite High Country

I NEVER SAW a discontented tree. They grip the ground as though they liked it, and though fast rooted they travel about as far as we do. They go wandering forth in all directions with every wind, going and coming like ourselves, traveling with us around the sun two million miles a day, and through space heaven knows how fast and far!

— JOHN MUIR

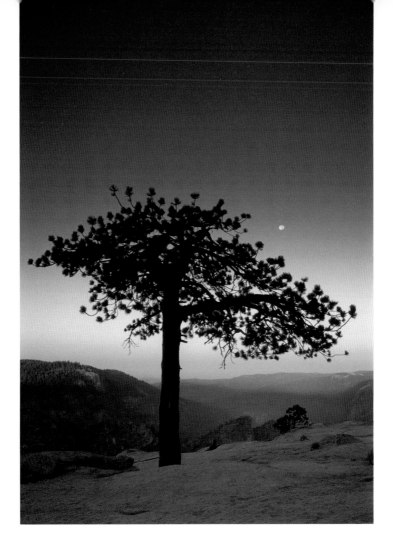

Jeffrey pine on Taft Point
Yosemite National Park

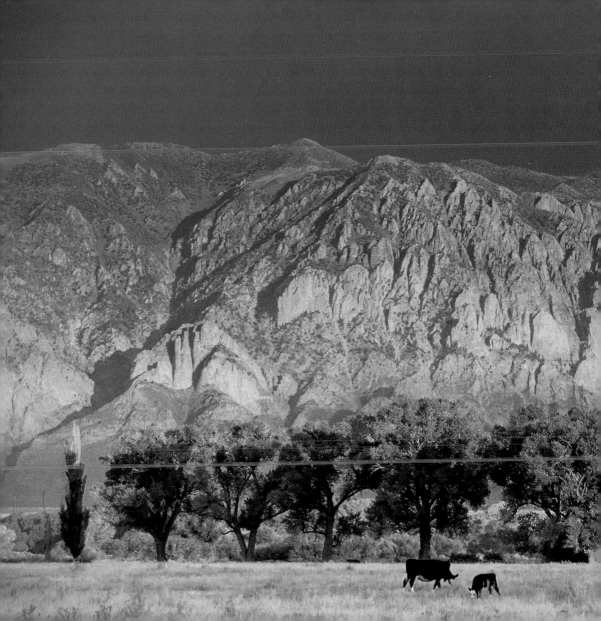

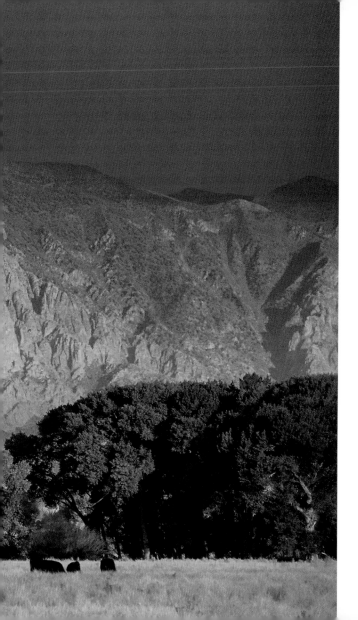

WHEN I AM in California, I am not in the west, I am west of the west.

— PRESIDENT
THEODORE ROOSEVELT

Sunrise over the Owens Valley
below Wheeler Crest
Eastern Sierra

IF EL DORADO is California's first large metaphor, continent's end is the second. In recent years a third has risen into view as a way of describing this region's place on the map and in the mind. *Pacific Rim* suggests a circle.... The term is geographical, and it also speaks to California's extraordinary cultural mix. This has been a culturally diverse region since 1769, when the Portolá expedition started up the coast from San Diego—a band of explorers that happened to include European Spaniards, *mestizos* (men of mixed blood), and soldiers of African descent.... California is a kind of borderland where the continent meets the sea, where Asia meets America, where cultures and subcultures touch, collide, ignite, and sometimes intermingle. And like the life...[move] in many directions at the same time.

— JACK HICKS, JAMES D. HOUSTON,
MAXINE HONG KINGSTON, AL YOUNG

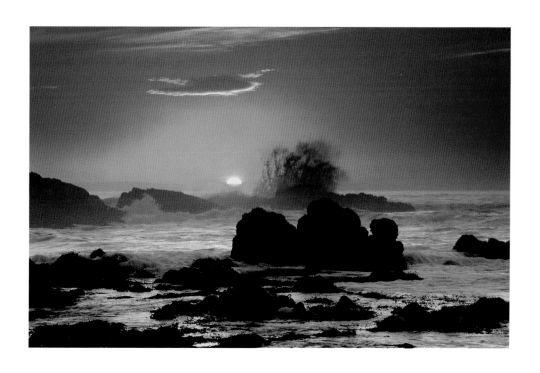

Sunset at Pescadero
San Mateo coast

(overleaf)
Dawn at Keyes View
Joshua Tree National Park

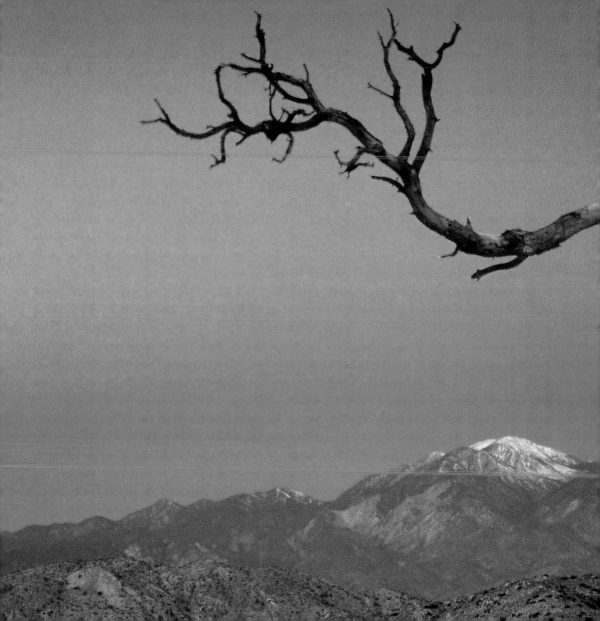

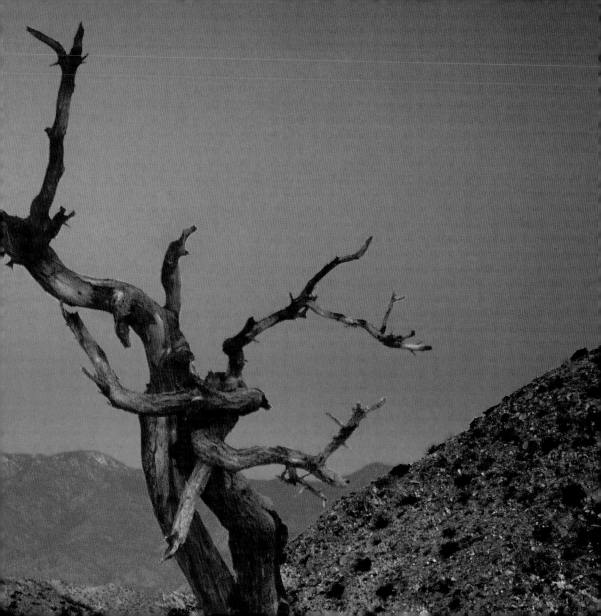

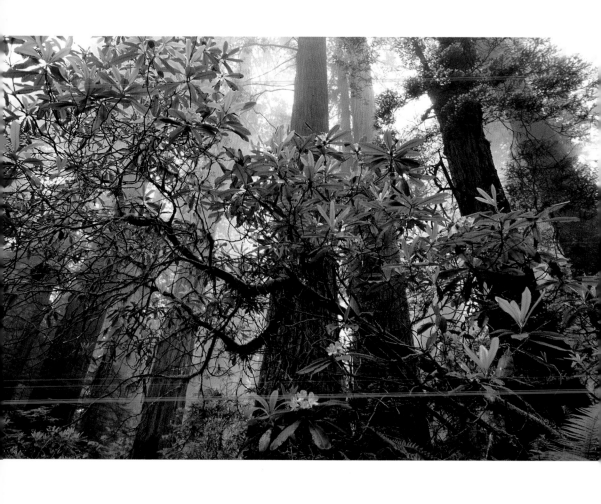

THE REDWOODS seem not to have really accepted the loss of the dinosaurs. In their silence they seem to wait for footsteps unheard these sixty million years.

— DAVID RAINS WALLACE

Rhododendrons in old-growth redwood forest
Del Norte Redwoods

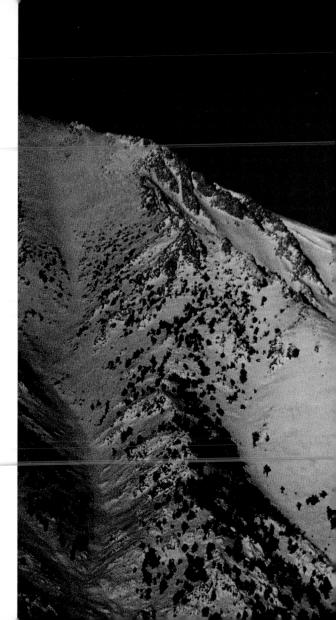

THE GENERAL view of the range from this, the Mono side, is far finer than from the other side.... The immense height of the chain above the plain, the abruptness of the declivity, the infinitely diversified forms, and the wonderful sharpness and ruggedness of the peaks...formed a picture of indescribable grandeur.

— Joseph Le Conte

Moonset at sunrise, Wheeler Crest
Eastern Sierra

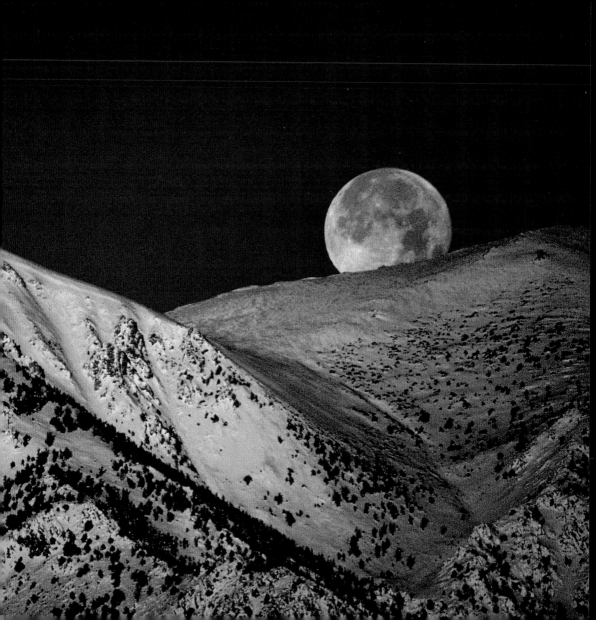

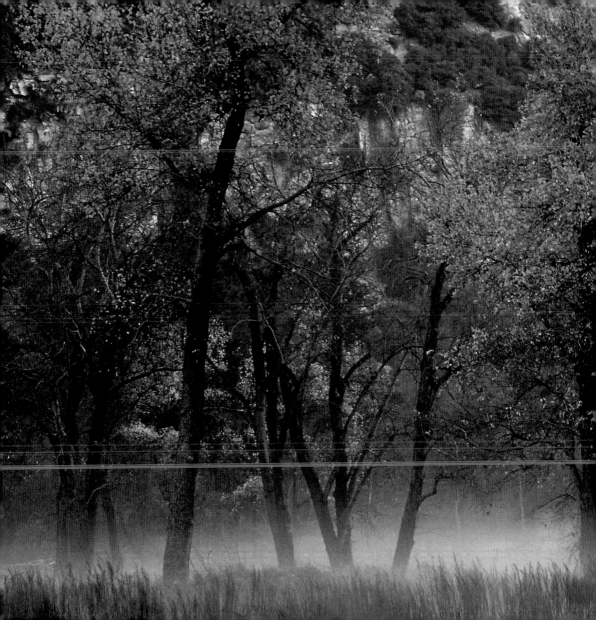

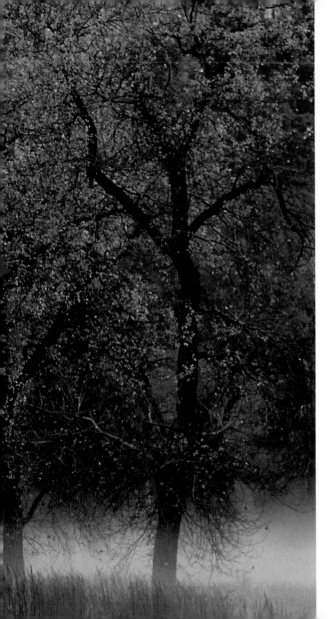

THE FIRST mention of the Golden State in literature, *Las sergas de Esplandian* by Garci Ordoñez de Montalvo, which antedated European discovery of the area by two decades, created a California of the mind that still intrigues....While 30 million human beings experience real life here every day, California remains at least as much state of mind as state of the union.

— GERALD W. HASLAM

Fall colors in morning mist
Yosemite Valley

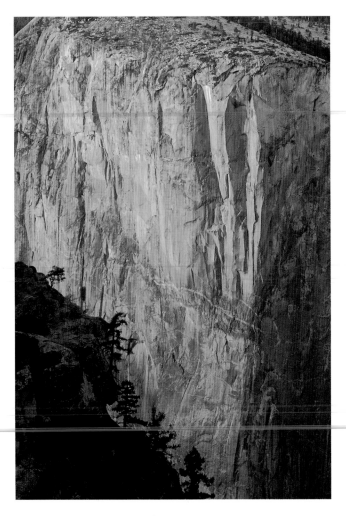

El Capitan
Yosemite National Park

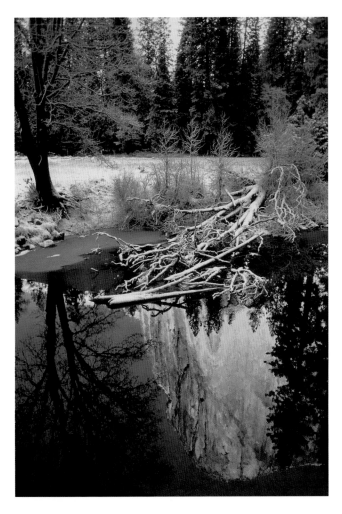

Frosted oak in the Merced River
Yosemite National Park

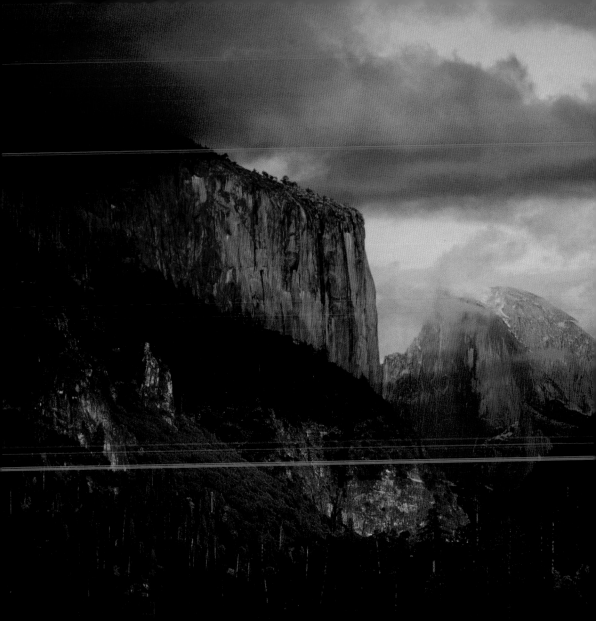

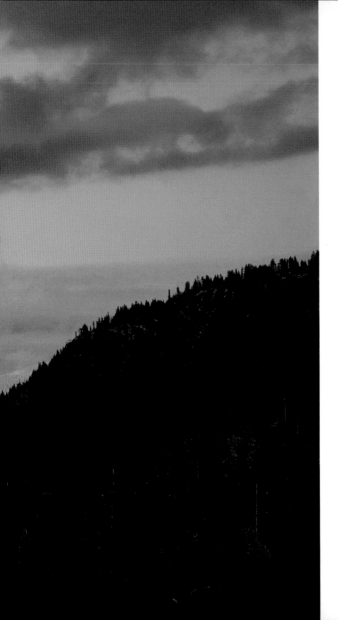

WONDER,
delight, freedom,
adventure, excitement,
are as much a part of
the mountains as peaks
and forests. Realism is
for tamer landscapes;
the mountains are
inescapably romantic.

— WALLACE STEGNER

95

Sunset after a storm
Yosemite National Park

(overleaf)
Moonrise
Anza-Borrego Desert

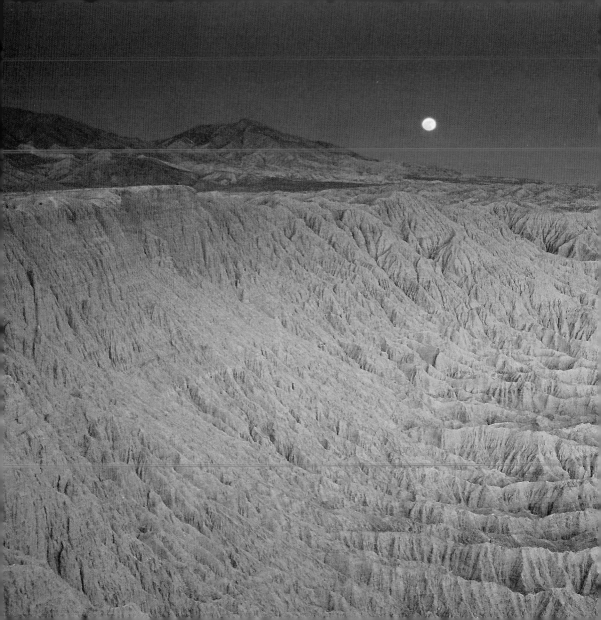

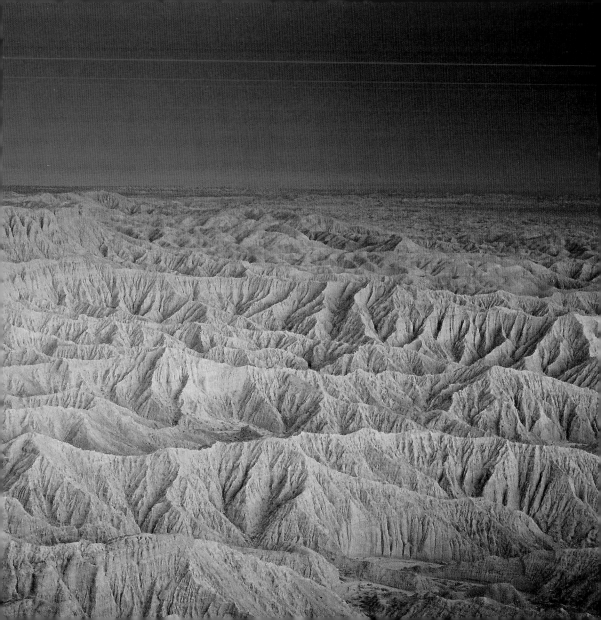

THE DAY ENDS with the blur
you wanted, full of watery hours,
the light weathered like aluminum,
gulls twining the air—summer's
floating script in the sky
refusing to pull together. The sun

breaks down each body
to silver, each bar of flesh
waist-deep in foam and brine.
The day flares out: wreckage
of orange on blue. Sea stars
wheel into place; like you

they witness the tide, the whitecaps
tipped with distance, the distance
large with blown sails and spray.
And the whole beachway goes cold
while strands of ocean light
sink like heavy netting.

— ROBERT VASQUEZ

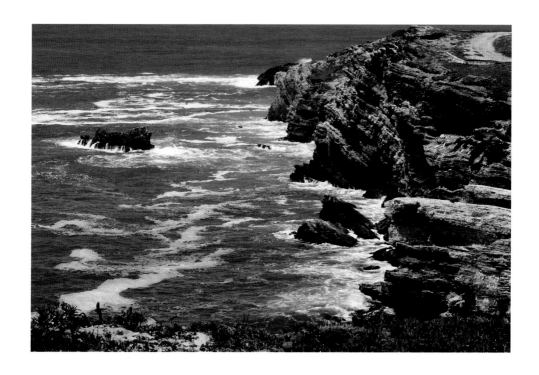

Point Arguello
Vandenberg Air Force Base

EVEN IN ITS GENTLEST MOODS the salt sea travails, moaning among the weeds or lisping on the sand; but that vast fog-ocean lay in a trance of silence, nor did the sweet air of the morning tremble with a sound.

— ROBERT LOUIS STEVENSON

(opposite)
Twilight surf
Marin Headlands

(overleaf)
Twilight over Mt. Tom from an Eastern Sierra pond
Inyo County

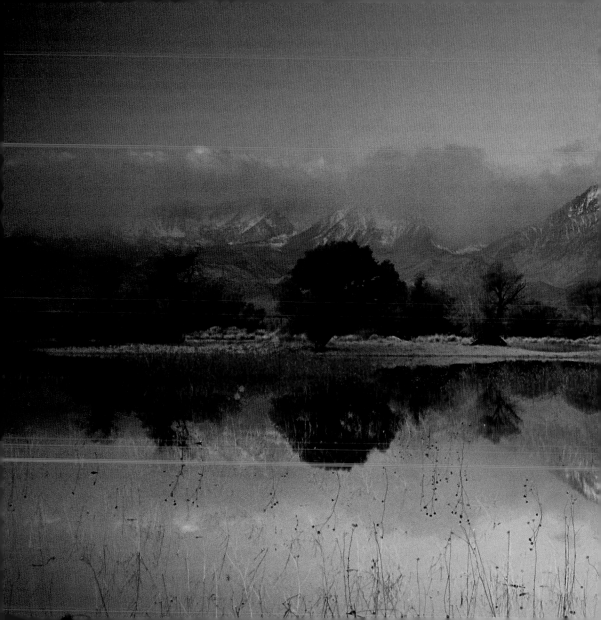

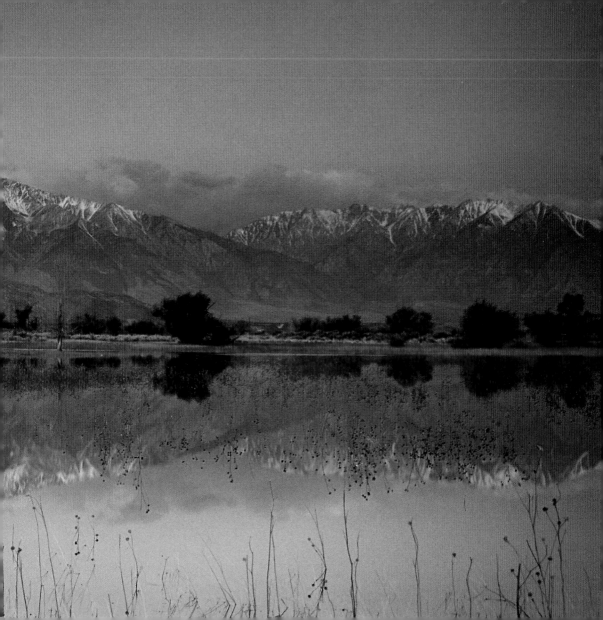

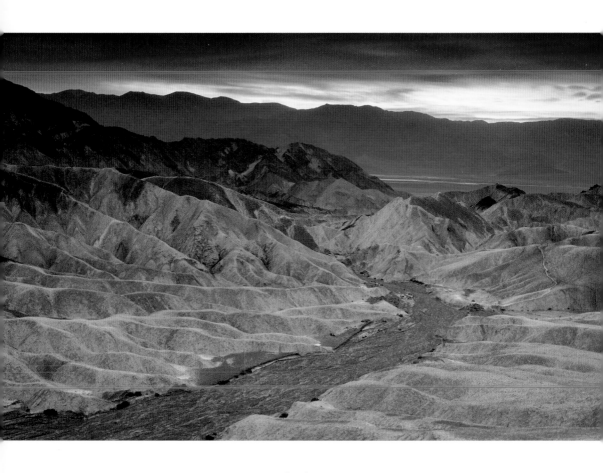

Zabriski Point
Death Valley

I THOROUGHLY ENJOYED the silence, which, gratefully contrasting with the surrounding tumult of form, conveyed to me a new sentiment. I have lain and listened through the heavy calm of a tropical voyage, hour after hour, longing for a sound; and in desert nights the dead stillness has many a time awakened me from sleep. For moments, too, in my forest life, the groves made absolutely no breath of movement; but there is around these summits the soundlessness of a vacuum. The sea stillness is that of sleep. The desert of death, this silence is the waveless calm of space.

— CLARENCE KING

AT THE END

of the ice age
 we are the bears,
we are the ravens,
We are the salmon
 in the gravel
At the end of an ice age.

— GARY SNYDER

Aerial of the Owens Valley
in winter
Eastern Sierra

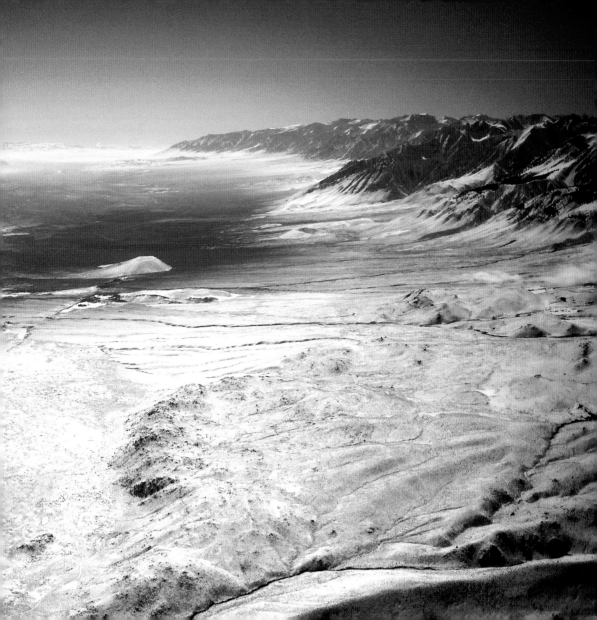

IT IS HARD TO ESCAPE the sense of mastery as the stars move in the wide clear heavens to risings and settings unobscured. They look large and near and palpitant; as if they moved on some stately service not needful to declare. Wheeling to their stations in the sky, they make the poor world-fret of no account. Of no account you who lie out there watching, nor the lean coyote that stands off in the scrub from you and howls and howls.

— MARY AUSTIN

Yosemite Falls by moonlight
Yosemite National Park

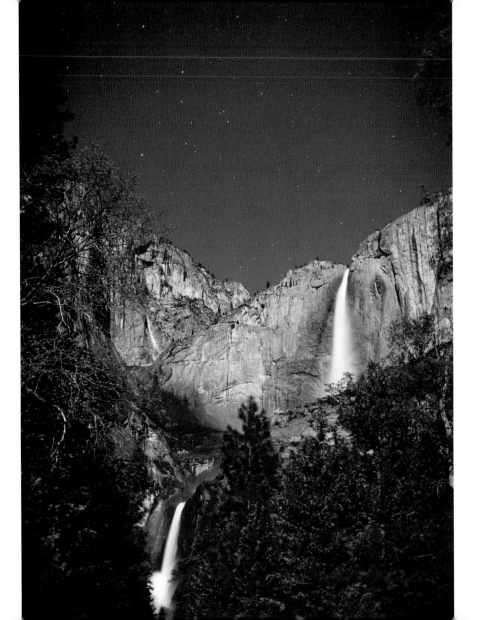

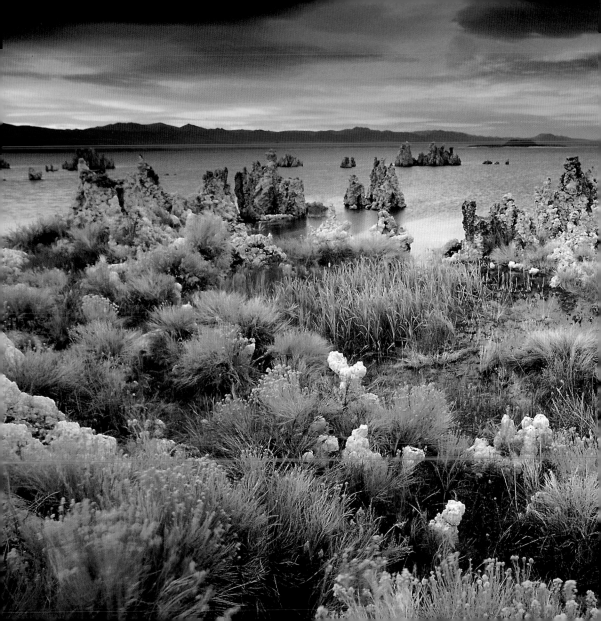

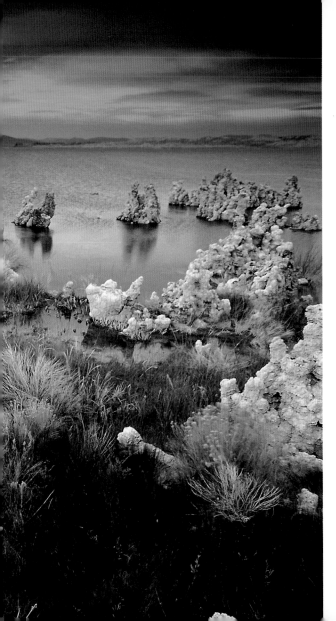

WE WILL SPREAD
the Garden. Our ideas
will seed the winds via
TV and radio and
records and fashions
and architectures. Our
battalions, invisible,
will win the day. The
next generation, in the
night, will be taken,
and wake little
knowing that they
have lost to Joy and
been won by
Jubilation.

— RAY BRADBURY

Stormy fall sunset
Mono Lake

THE WHOLE WORLD is an art gallery when you're mindful. There are beautiful things everywhere—and they're free.

— CHARLES TART

112

(opposite)
Winter sunrise on bristlecone pine
White Mountains

(overleaf)
Earth shadow at dawn
Mt. Tamalpais State Park

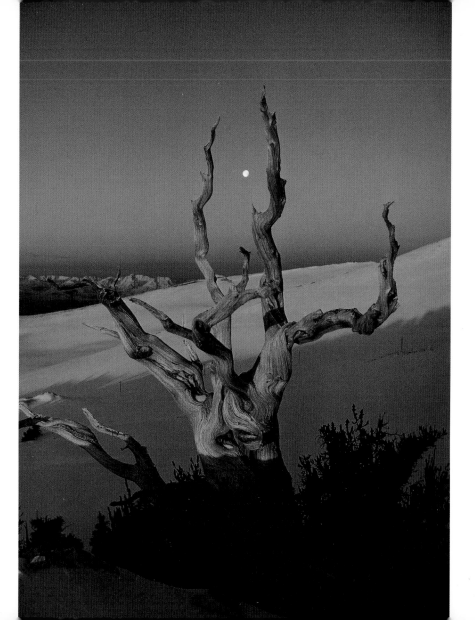

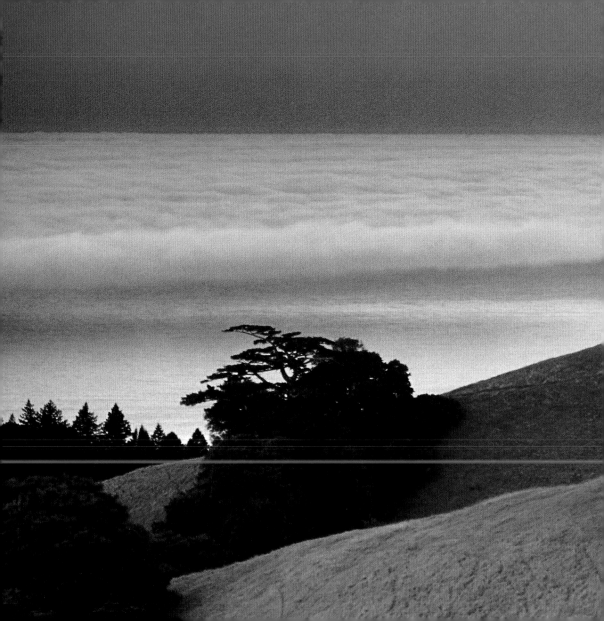

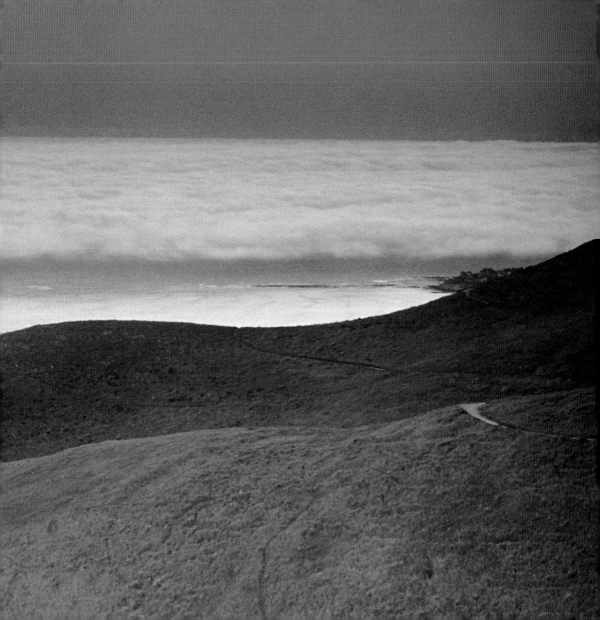

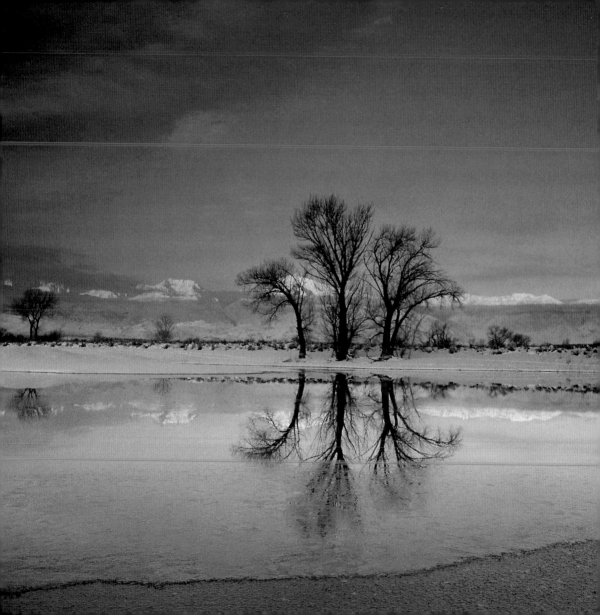

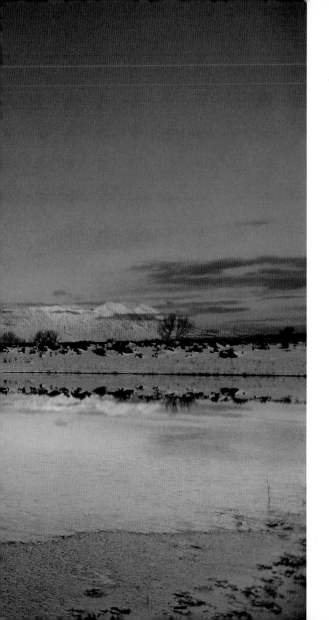

ONCE from eastern
ocean to western
ocean, the land
stretched away
without names.
Nameless headlands
split the surf;
nameless lakes
reflected nameless
mountains; and
nameless rivers
flowed through
nameless valleys into
nameless bays.

— GEORGE STEWART

*Winter sunrise over an Owens
Valley pond*
Eastern Sierra

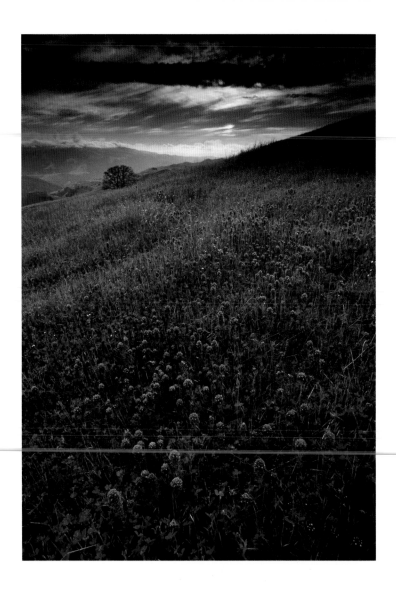

OUR ROOTS are in the dark; the earth is our country. Why did we look up for blessing—instead of around, and down? What hope we have lies there…in the earth we have looked down upon. Not from above, but from below. Not in the light that blinds, but in the dark that nourishes, where human beings grow human souls.

— URSULA K. LE GUIN

Owl's clover
Ohlone Wilderness

[THE SIERRA] has the brightest weather, brightest glacier-polished rocks, the greatest abundance of irised spray from its glorious waterfalls, the brightest forests of silver firs and silver pines, more starshine, moonshine, and perhaps more crystalshine than any other mountain chain, and its countless mirror lakes, having more light poured into them, glow and spangle most. And how glorious the shining after the short summer showers and after frosty nights when the morning sunbeams are pouring through the crystals on the grass and pine needles, and how ineffably spiritually fine is the morning-glow on the mountain-glow on the mountaintops and the alpen-glow of evening. Well may the Sierra be named, not the Snowy Range, but the Range of Light.

— JOHN MUIR

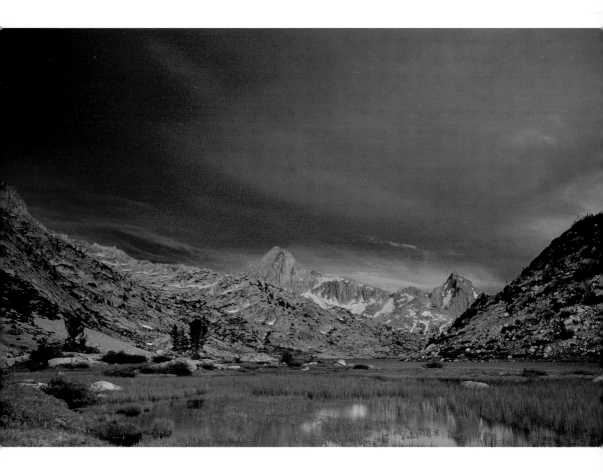

Evolution Lake
High Sierra

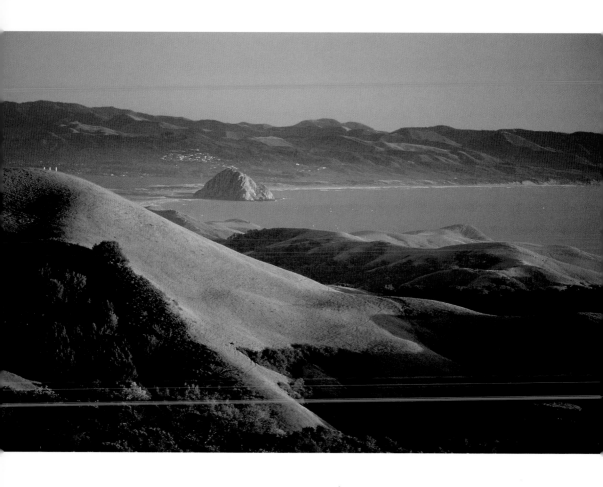

Morro Rock
Morro Bay

MANY PEOPLE in the East (or "back East," as they say in California, although not in LaScala or Ernie's) do not believe this. They have been to Los Angeles or to San Francisco, have driven through a giant redwood and have seen the Pacific glazed by the afternoon sun off Big Sur, and they naturally tend to believe that they have in fact been to California. They have not been, and they probably never will be, for it is a longer and in many ways a more difficult trip than they might want to undertake, one of those trips on which the destination flickers chimerically on the horizon, ever receding, ever diminishing....California is a place in which a boom mentality and a sense of Chekhovian loss meet in uneasy suspension; in which the mind is troubled by some buried but ineradicable suspicion that things had better work here, because here, beneath that immense bleached sky, is where we run out of continent.

— JOAN DIDION

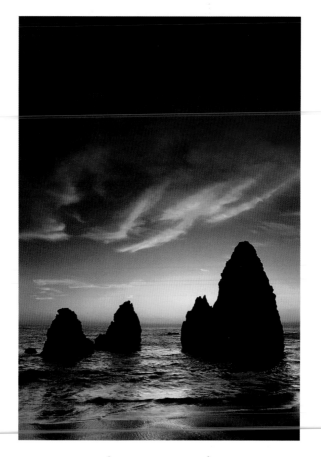

Sunset over sea stacks
Marin Headlands

(opposite)
Cactus
Santa Barbara coast

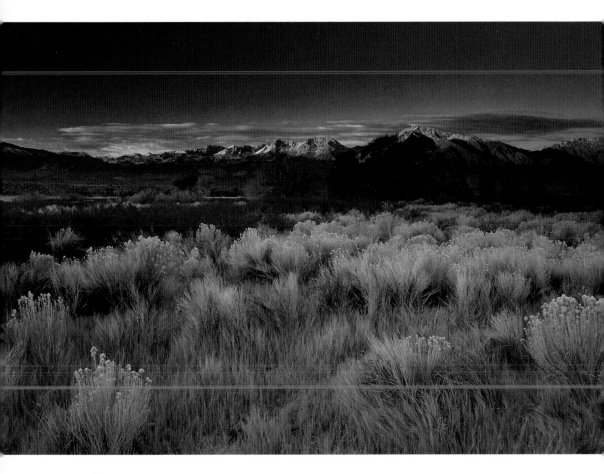

Fall sunrise in the High Sierra
Owens Valley

WHAT IS THERE that confers the noblest delight?
What is that which swells a man's breast with pride above
that which any other experience can bring to him?
Discovery! To know that you are walking where none
others have walked; that you are beholding what human
eye has not seen before; that you are breathing a virgin
atmosphere. To give birth to an idea, to discover a great
thought—an intellectual nugget, right under the dust of a
field that many a brain-plough had gone over before. To
find a new planet, to invent a new hinge, to find a way to
make the lightnings carry your messages…that is the idea.

— MARK TWAIN

(overleaf)
Winter sunset, Gates of the Valley
Yosemite National Park

127

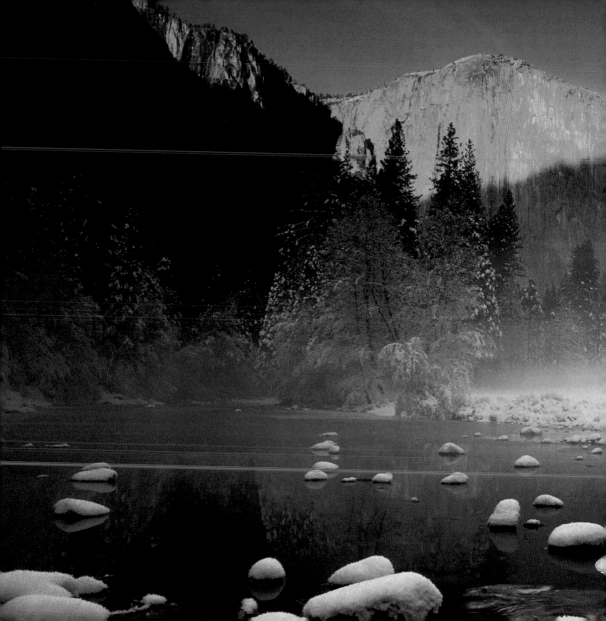

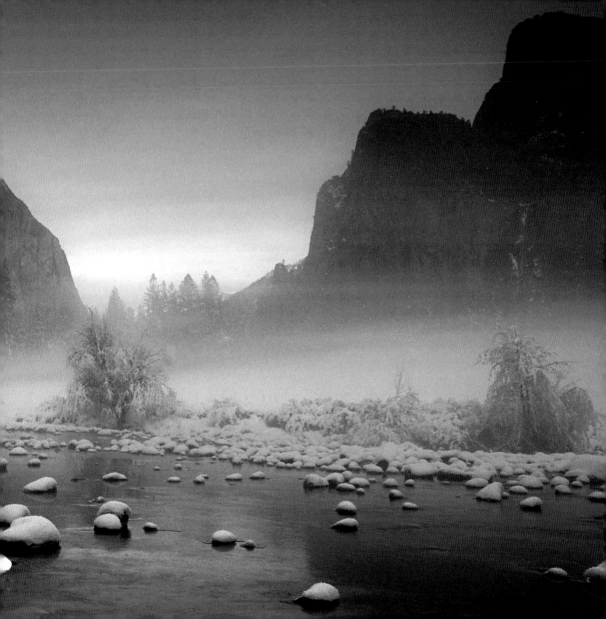

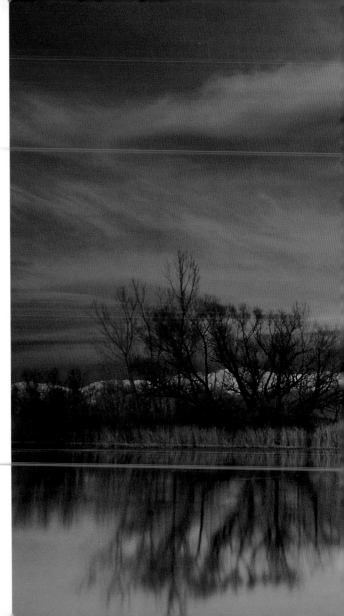

WE SIMPLY NEED
that wild country
available to us, even if
we never do more than
drive to its edge and

130 look in. For it can be a
means of reassuring
ourselves of our sanity
as creatures, a part of the
geography of hope.

— WALLACE STEGNER

Sierra Wave over
Owens Valley near Bishop
Mill Pond

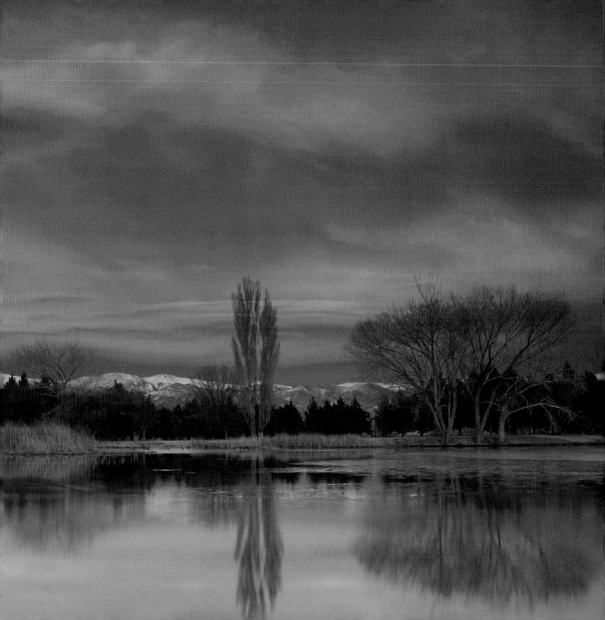

FACING WEST from California's shores,
Inquiring, tireless, seeking what is yet unfound,
I, a child, very old, over waves, towards the house of
maternity, the land of migrations, look afar,
Look off the shores of my Western sea, the circle
almost circled;
For starting westward from Hindustan, from the
vales of Kashmere,
From Asia, from the north, from the God, the sage,
and the hero,
From the south, from the flowery peninsulas and
the spice islands,
Long having wander'd since, round the earth
having wander'd,
Now I face home again, very pleas'd and joyous,
(But where is what I started for so long ago?
And why is it yet unfound?)

— WALT WHITMAN

Post Ranch
Big Sur coast

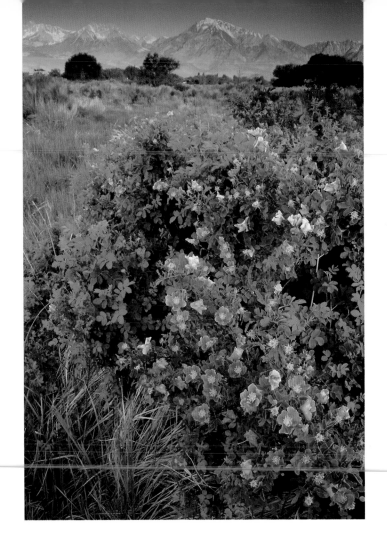

134

Wild roses
West Bishop

I GAVE HEED to the confiding stream, mingled freely with the flowers and light, and shared in the confidence of their exceeding peace.

— JOHN MUIR

MY SIMPLE PRAYER is that in all things
I learn to love well.
That I learn to touch the ever-changing seasons of life with
a great heart of compassion.
That I live with the peace and justice I wish for the earth.
That I learn to care fully and let go gracefully.
That I enjoy the abundance of the earth and return to it
from the natural generosity that is our human birthright.
That through my own life, through joy and sorrow in
thought, word, and deed,
I bring benefit and blessings to all that lives.
That my heart and the hearts of all beings learn to be free.

— JACK KORNFIELD

136

(opposite)
Wild mountain lion below Grouse Mountain
Bishop Creek, Eastern Sierra

(overleaf)
Monterey pine at sunset
Mt. Tamalpais, Marin County

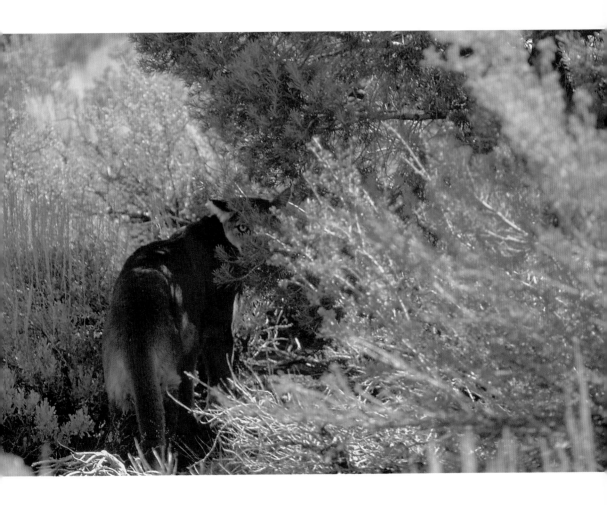

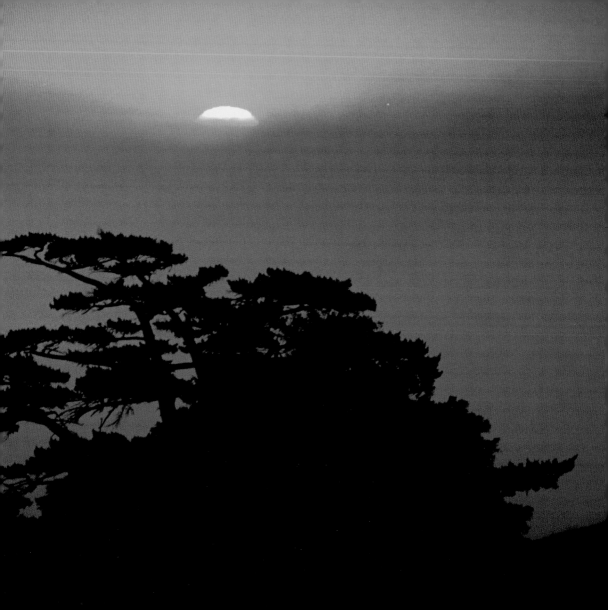

CALIFORNIA'S future and its promise are
nothing less than the future and promise of
America. It has a California context, to be sure,
but it is nothing separate from the dreams and
hopes and aspirations of all the American people in
their collective struggle to create a decent, fair, and
secure republic.

— KEVIN STARR, state librarian of California

140

Bixby Creek
Big Sur coast

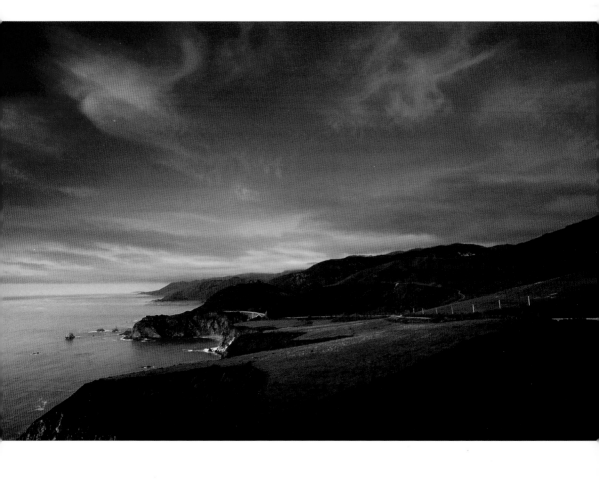

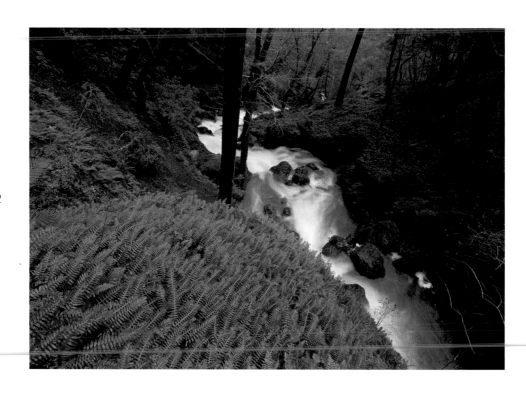

Cataract Falls
Mt. Tamalpais, Marin County

WE HAVE LEARNED the great secret along the way from surf to mountains: you don't have to look busy to be busy. You don't have to scowl and pout and paw the turf and summon ghosts of Jung and séances of Freud to prove yourself an intellectual pomegranate ripe with concepts, creative papa to the world of philosophies, technologies, science, and arts.

— RAY BRADBURY

143

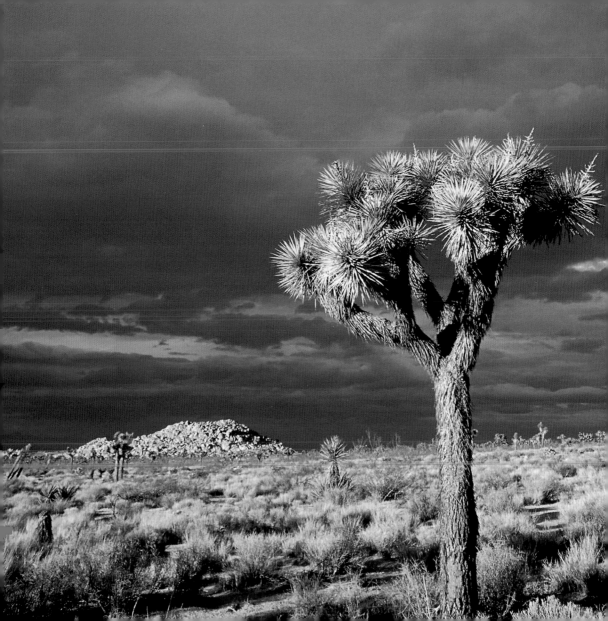

TIME in the great deserts of the West is very different from city time. Because the earth's crust is sliced open, and so many objects from past history lie preserved in the dry, clean air, desert time is like layers of clear plate glass. You can drop down through them, intersecting lives separated by centuries. In the desert, antiquity is interlayered with the present.

— SUSAN ZWINGER

145

Joshua tree
Joshua Tree National Monument

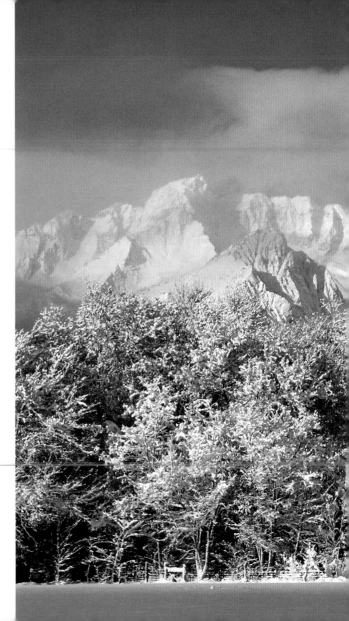

AFAR the bright
Sierras lie
A swaying line of
snowy white,
A fringe of heaven
146 hung in sight
Against the blue base
of the sky.

— JOAQUIN MILLER

Winter sunrise in
the Eastern Sierra
Owens Valley near Bishop

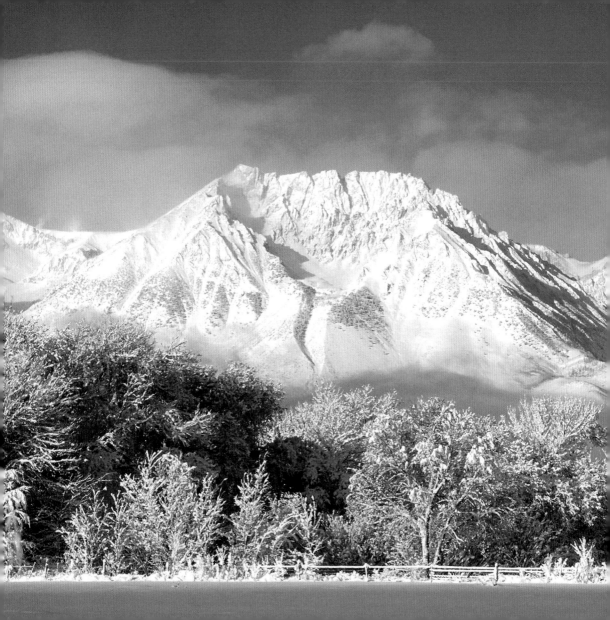

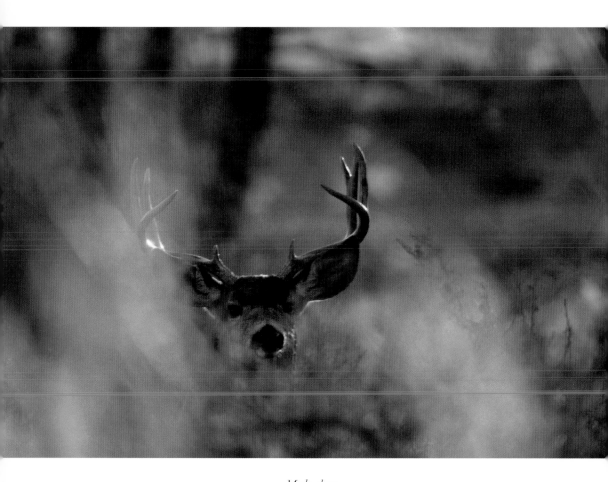

Mule deer
Eastern Sierra

IT WAS THE GREEN HEART of the canyon.... Here all things rested. Even the narrow stream ceased its turbulent down-rush long enough to form a quiet pool. Knee-deep in the water, with drooping head and half-shut eyes, drowsed a red-coated, many-antlered buck.

— Jack London

(overleaf)
Mountain lion kitten in sagebrush
Sagehen Summit, near Mono Lake

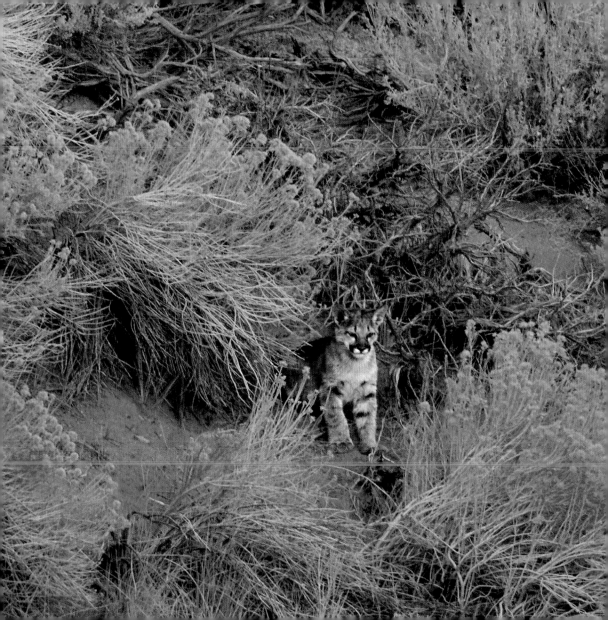

IF WE ARE ALWAYS arriving and departing, it is also true that we are eternally anchored. One's destination is never a place but rather a new way of looking at things.

— HENRY MILLER

Sheltered aspen displaying fall color
North Lake, Eastern Sierra

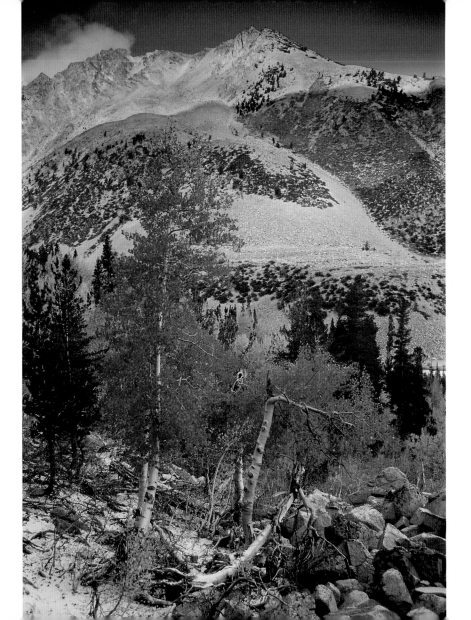

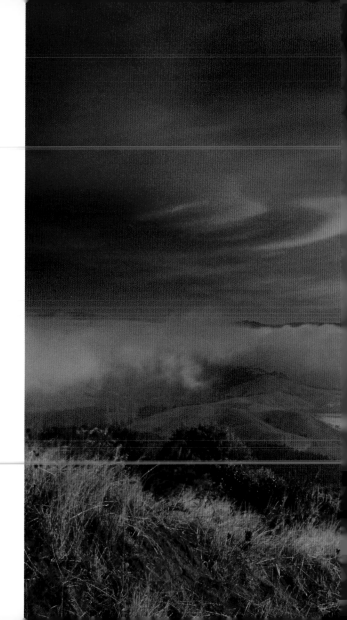

THE ATTRACTION

and superiority of
California are in its days.

It has better days, and
more of them, than any
other country.

— RALPH WALDO EMERSON

*Morning fog around Briones
Lake from Vollmer Peak*
Berkeley Hills

(overleaf)
Snow geese
Klamath Wildlife Refuge

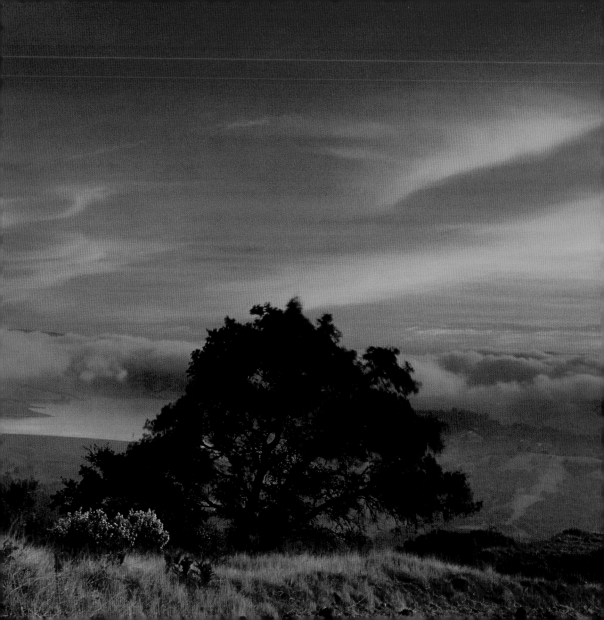

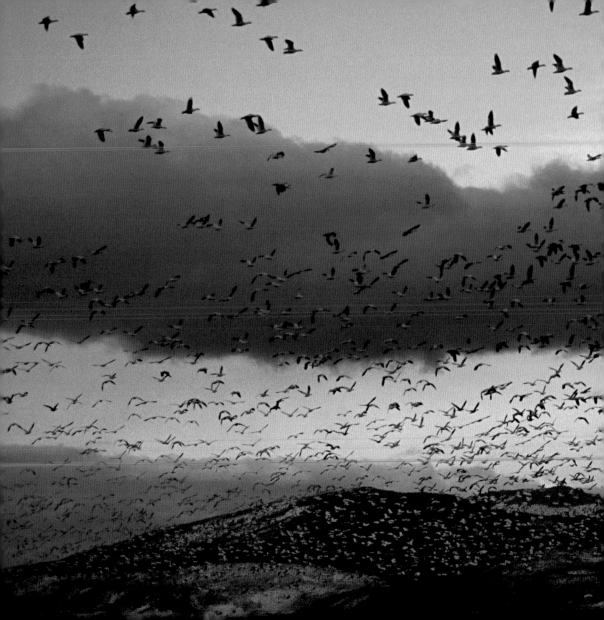

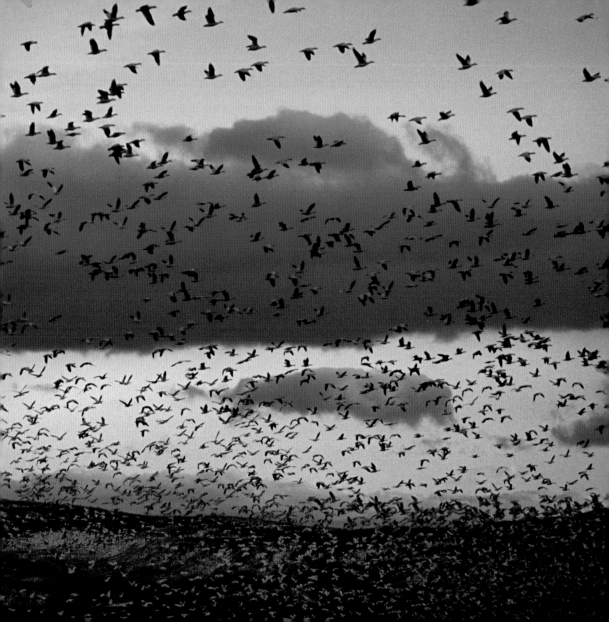

158

Published in 2002 by Welcome Books®
in cooperation with Via Books

Welcome Books® is an imprint of Welcome Enterprises, Inc.

VIA Books is a division of the California State Automobile
Association (CSAA)

Welcome Enterprises, Inc.
6 West 18th Street
New York, NY 10011
(212) 989-3200; Fax (212) 989-3205
e-mail: info@welcomebooks.biz
www.welcomebooks.biz

Publisher: Lena Tabori
Art Director: Gregory Wakabayashi
Designer: Mia Ihara
Project Director: Natasha Tabori Fried
Editorial Assistant: Lawrence Chesler

Distributed to the trade in the U.S. and Canada by
Andrews McMeel Distribution Services
Orders Department and Customer Service (800) 943-9839
Orders-Only Fax (800) 943-9831

Compilation © 2002 California State Automobile Association (CSAA)
Design © 2002 Welcome Enterprises, Inc.
Photographs © 2002 Galen Rowell/Mountain Light
www.mountainlight.com

Additional copyright information available on page 159.

Library of Congress Cataloging-in-Publication Data

Rowell, Galen A.
 California the Beautiful / photographs by Galen Rowell.
 p. cm.
 ISBN 0-94807-67-3
 1. California—Pictoral works. 2. Natural History—
California—Pictoral works. I. Title.
 F862 .R79 2002
 508.794'022 2—dc21
200056774

Printed in Hong Kong

First Edition

10 9 8 7 6 5 4

159

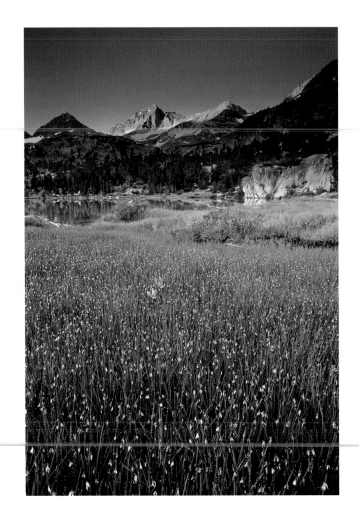

Shooting star beneath Bear Creek Spire
Little Lakes Valley, Eastern Sierra